IMAGES
of America

WILMETTE

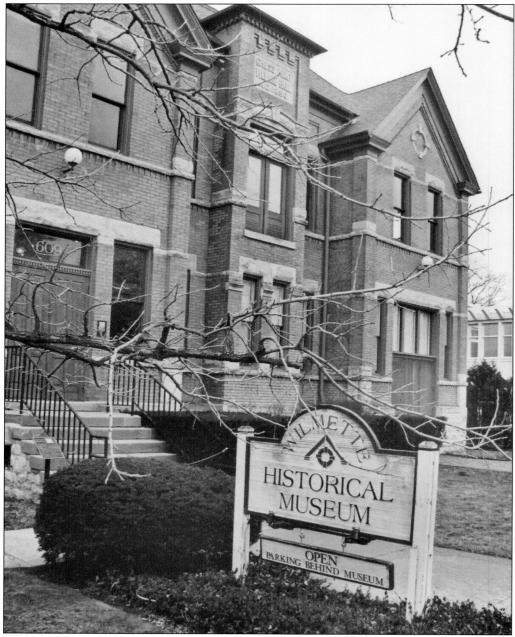

The Wilmette Historical Museum, established by the Village of Wilmette in 1951, is located in the historic Gross Point Village Hall. Part of the work of the museum is to preserve this 1896 building and to make it a venue for lively events that everyone interested in the history of the local area can enjoy. (Photograph by Ron Testa.)

ON THE COVER: Downtown Wilmette in 1937 included the Wilmette Theatre, Wolff Hardware, and Weeks Dining Room. The street is no longer paved with bricks, but in other respects, this block of Central Avenue looks very similar today. (Courtesy of the Wilmette Historical Museum.)

IMAGES
of America

WILMETTE

Kathy Hussey-Arntson and Patrick Leary

ARCADIA
PUBLISHING

Published by Arcadia Publishing
Charleston, South Carolina

Printed in the United States of America

Library of Congress Control Number: 2012934474

For all general information, please contact Arcadia Publishing:
Telephone 843-853-2070
Fax 843-853-0044
E-mail sales@arcadiapublishing.com
For customer service and orders:
Toll-Free 1-888-313-2665

Visit us on the Internet at www.arcadiapublishing.com

*To our families—Dale and Emily Arntson and Sherrill
Weaver—who encouraged and supported us throughout
this project and who bring joy to our lives every day*

CONTENTS

ACKNOWLEDGMENTS

When writing the community's history, we drew upon the work of those people who came before us and who shared our enthusiasm. Ye Olde Town Folk, the village's first historical group, began in the 1890s to record the memories of early residents. Later, local historians such as Harriet Joy Scheidenhelm, Herbert Mulford, George Bushnell, and David Leach Jr. wrote extensively about Wilmette's past. We owe a debt of gratitude to each of them.

Wilmette residents are passionate about their community and its legacy, and the museum flourishes because of that community spirit. Hundreds of volunteers have helped preserve this history, and while it is not possible to name each of them, we gratefully acknowledge their contributions. For this project, we would especially like to thank Diane Stumpf and Barbara Bennett, who have volunteered their time to digitize our collection of over 10,000 images.

We also wish to acknowledge the ongoing support of the Village of Wilmette's trustees and employees. Special thanks go to Village President Christopher Canning for sharing an interest in our work. The collections of the Wilmette Historical Museum are owned by the Village of Wilmette, and therefore, thanks are also due to Village Manager Timothy Frenzer for granting us permission to use the museum's photographs for this project. All photographs in the book are from the museum's collections, unless otherwise noted.

The board of directors of the Wilmette Historical Society has also been extremely supportive of this book, from reviewing the contract to staffing the museum while we finished the manuscript. Our colleagues Rachel Kuhn and Jane Textor have been ready with assistance, feedback, humor, and snacks to keep us going. Thank you so much.

Finally, we would like to thank those who have donated photographs to the museum over the past 60 years and those who took the photographs. Local photographers Thomas Gillette, Al Ackermann, Harvey Steffens, Evelyn Schuber, John McDonough, and Ron Testa—to name a few—captured people and scenes for all of us to enjoy. May their work inspire present and future Wilmette residents of all ages to continue to document life in this village.

INTRODUCTION

Wilmette has been shaped by many things: its location on the shores of Lake Michigan, its nearness to Chicago, the fertility of its soil, the coming of the railroad, and periods of economic calamity, wartime, and prosperity. Most of all, it has been shaped by all those who have called it home over the past 150 years and more and how they have experienced life in this community. The images in this book reflect many of those experiences.

Unsurprisingly, none of those images date from the earliest periods of Wilmette's recorded history, when Archange Ouilmette and her husband, Antoine, moved north from the first settlement in Chicago to take up residence in a cabin by Lake Michigan. Long after the Ouilmettes had left for Iowa to join her Pottawatomi kin in 1838, the area remained sparsely settled, save for a few hardy pioneers near the lake and the first families who had begun to farm the area west of the ridge along which Ridge Road runs today.

This east-west duality would remain a feature of Wilmette's history from the 1830s to the present day, for it is a history interestingly complicated by having been a tale of two very different communities: the Village of Wilmette, incorporated in 1872 by mostly Anglo, Protestant settlers from the East, who hoped to develop the village as a commuter suburb; and, to the west, the Village of Gross Point, founded in 1874 by mostly Roman Catholic, German-speaking farmers, craftsmen, and shop owners. Throughout the 19th century and into the early 20th, their histories run parallel to one another—from the hardships of early settlement to the building of roads and civic buildings to the shared experience of World War I. Father William Netstraeter, the longtime priest of St. Joseph's Church, which primarily served the people of Gross Point, although it stood on the Wilmette side of the border, even served for a time as president of the Village of Wilmette. On one issue in particular, however, the two communities were in fierce conflict: the politics of alcohol. The long efforts by temperance advocates in Wilmette and other nearby communities to shut down the saloons that lined Ridge Road in Gross Point, saloons that played a vital part in the financial and community life of that village, were eventually successful. That success helped to doom the Village of Gross Point as an independent municipality. After 1924, when Wilmette formally annexed Gross Point, their stories nominally merge into one, and yet these areas of the village have retained distinctive identities.

To have lived in Wilmette, whether on the east side or the west, and especially to have grown up here, is nevertheless to have many memories of shared experiences that bind the community into one, linking each generation to the next. Summer afternoons on Wilmette Beach, catching the "L" at Fourth Street and Linden Avenue, eating ice cream at Peacock's or Homer's, skating at the Village Green or Centennial Park, picking out a Halloween pumpkin at a farm stand, going to the movies at the Teatro del Lago or the Wilmette Theatre, shopping at Edens Plaza, taking in a Little League game at Roemer Park, sitting on the hill at Gillson Park to watch the fireworks on the third of July—these and a thousand similar experiences have gone to make up life in this one modestly sized but proud and vibrant village by the lake.

The history of any place, however small, is richer than any photographs can show, and in putting this book together, we have been painfully aware that some of the best and most significant stories from Wilmette's history simply cannot be told with images. By the same token, some of the loveliest and most interesting photographs depict scenes about which we know relatively little. What follows, then, is not a history of Wilmette in images but, rather, a selection of some of the best historic images of Wilmette. Out of the Wilmette Historical Museum's collection of over 10,000 photographs of people, places, and events, we have chosen some because they are rare, others because they are charming, and still others because they seem so characteristic of their time and place. All of them are favorites, and all of them speak to what is so special about this community.

One

SETTLEMENT TO SUBURB

Little is known of the first people to have lived in what is now the Wilmette area. Hunter-gatherers left behind a few stone tools and bits of pottery; later, in the 1700s, the Miami and Pottawatomi tribes moved into the region and established camps near the lake. Native Americans were forced out of the region by treaties in the 1820s and 1830s. The first settlers known to history by name were Antoine and Archange Ouilmette and their family, after whom the village was later named. The Ouilmettes sold most of their extensive land holdings in the early 1840s.

The first people of European descent to settle in this area arrived not long before the Ouilmettes and most of the Native Americans left in the 1830s. They found here a lakeshore of high bluffs and thick, dark woods of elm, oak, and ash, crisscrossed by a few ancient trails. German immigrants who arrived in the 1830s farmed the land west of what became Ridge Road and named the township New Trier, after their hometown of Trier in Germany. In the 1840s and 1850s, entrepreneurs from Upstate New York and the Eastern Seaboard, like Alexander McDaniel, John G. Westerfield, Henry Dingee, and John Gage, bought large tracts of land east of the ridge.

The hard work of these early settlers transformed the quality of life in Wilmette during the 1800s. Marshes were drained, streets and sidewalks laid down, churches and schools built, businesses opened, and the railroad depot established. Effective local government was an essential step forward: the Village of Wilmette was incorporated in 1872, while neighboring Gross Point followed suit in 1874. By 1900, Wilmette had grown from a tiny settlement in the forest to a flourishing Chicago suburb, combining the quiet and neighborliness of small-town life with many of the amenities of the big city.

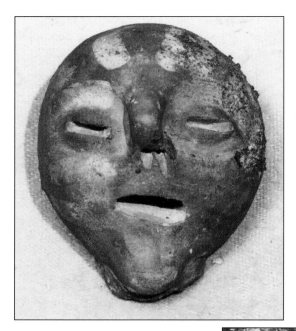

This haunting ceramic figure of a human face was originally part of a larger Native American object, probably a bowl from the Mississippian period, 1100–1500 AD. The face was excavated in 1922 during a construction project behind J. Melville Brown's house at 738 Eleventh Street.

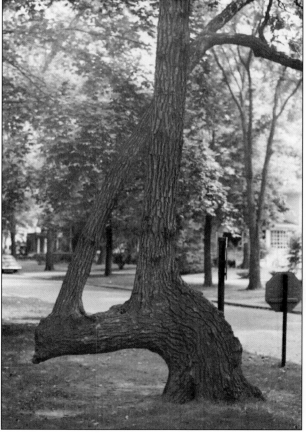

Forest and marshland trails were a prominent feature of the Wilmette area. Many local historians believe that Native Americans used bent saplings as trail markers. This trail tree at Tenth Street and Greenwood Avenue was one of several marked with a plaque by the Wilmette Historical Commission in the 1950s. All of these trees have since succumbed to age and weather.

Thick forests stretched from the ridge (where Ridge Road runs today) to the lakeshore in early Wilmette. Even after settlement was well advanced in the late 1800s, much of the village retained this woodland character. This photograph from the 1890s album of a Wilmette family shows a girl gathering butternuts along a path through the dense woods near their home.

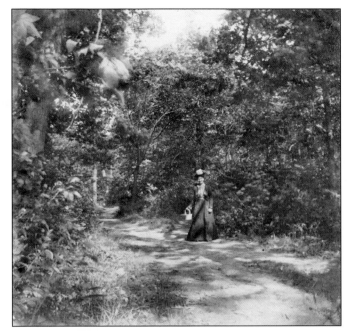

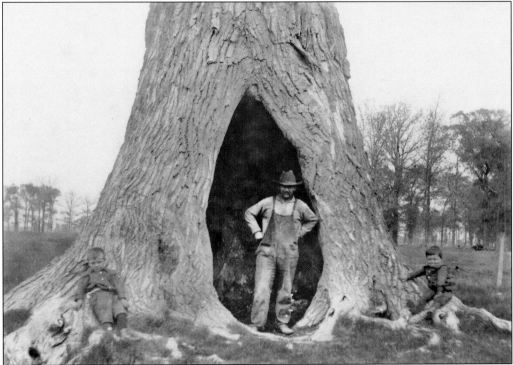

The Council Tree, an early landmark that could be seen for miles, stood near what is now Edens Expressway at Glenview Road. It was said to have been a sacred spot to Native Americans. A popular pastime was to have one's photograph taken in the rotted-out base of this enormous cottonwood tree, as this farmer and his boys have done. (Photograph by Dr. Byron Stolp.)

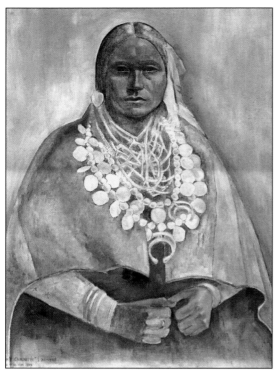

With her husband, Antoine, a French Canadian guide and trader, Archange Ouilmette, of half-French and half-Pottawatomi descent, was one of the earliest settlers of Chicago. The Treaty of Prairie du Chien in 1829 granted her 1,280 acres stretching from the lakeshore west to what is now Fifteenth Street, and bounded north and south by Elmwood Avenue and Central Street, Evanston. In this 1934 painting, local artist George Lusk imagines Archange in traditional Pottawatomi garb.

The Ouilmettes built their cabin in about 1829 just north of present-day Lake Avenue, near the lakeshore, and managed a sizable farm. After their departure in 1838 to join other Pottawatomi families in Iowa, the cabin stood until the 1860s on the farm owned by the Westerfield family. Many years later, Charles P. Westerfield painted this watercolor of the cabin from memory.

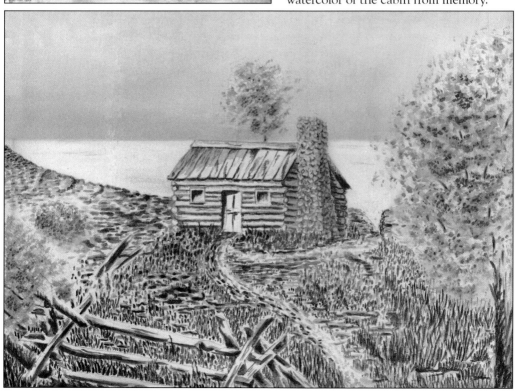

Alexander McDaniel first visited this area in 1836, staying overnight with the Ouilmettes. He later built a house at the southeast corner of Central and Wilmette Avenues. Active in the real estate business, McDaniel helped to found the Village of Wilmette and served as its first postmaster.

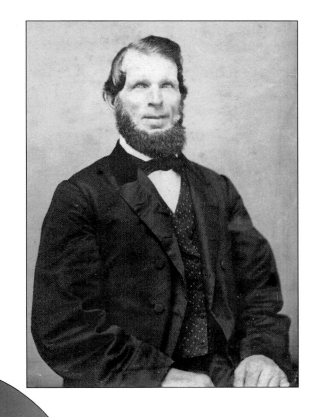

Benjamin Franklin Hill arrived in the area as a boy with his parents, Arunah and Olivia Hill, in 1836. The Hills bought a farm here a year later and built a cabin on it near where St. Joseph's Church now stands. Later, with partner Hubbard Latham, Hill was active in building local houses in the area of Fourth Street and Linden Avenue. Maple Avenue was formerly called Hill Street in his honor.

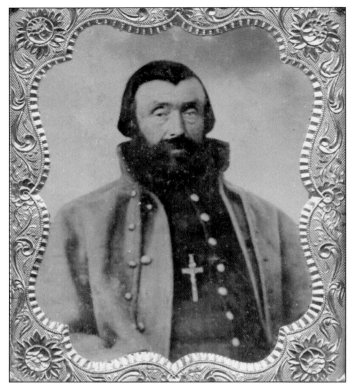

Sparsely settled as it was in the 1860s, the Wilmette/ Gross Point area sent about 40 men off to the Civil War. John Fiegen (shown here) was 44 years old and living on Illinois Road when he joined the 23rd Illinois Infantry on March 2, 1862. Fiegen was captured by the Confederates at the Second Battle of Kernstown and died in the notorious prison at Andersonville, Georgia, on August 20, 1864.

Charles P. Westerfield served in the 8th Illinois Cavalry, Company F, during the Civil War. This calling-card photograph is typical of the period. After the war ended, Charles returned to the Wilmette area, where his father became the village's first president. Charles later served as village clerk until he and his wife moved to Waukegan.

John Gage never lived in Wilmette, but he bought land here early on, and his sons and their families played key roles in the development of the village. At one time, the Gages owned most of Wilmette north of Elmwood Avenue, including "No Man's Land." Shown here in 1890, from left to right, are (seated) Portia Gage, John Gage, and son Asahel Gage; (standing) sons Henry H. Gage, Augustus N. Gage, and John P. Gage.

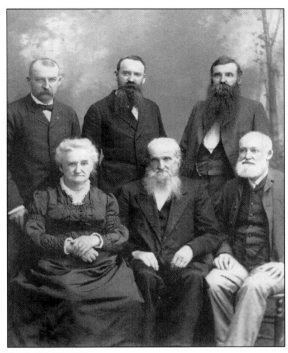

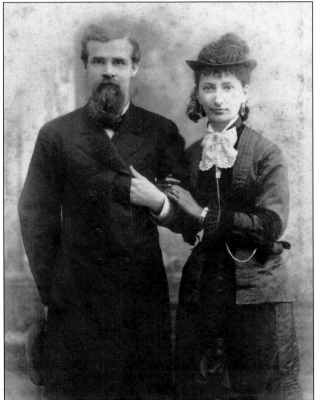

Byron C. Stolp (1850–1917) was Wilmette's first doctor. He and his wife, Carrie (pictured here) came to this area in the summer of 1874. Dr. Stolp delivered most of the children born to the first generation of families who moved to the newly incorporated village and became a much-loved local figure. He ranged far and wide by horse-drawn carriage, visiting his patients.

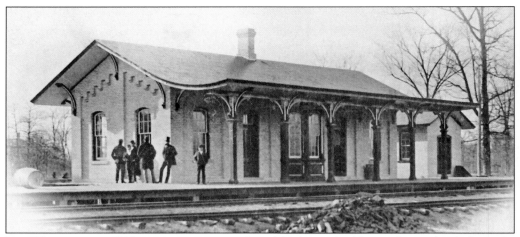

In 1873, prominent Wilmette citizens contributed $3,500 to build this elegant brick depot for the newly incorporated village. The depot also served the village as a meeting room and polling place for many years.

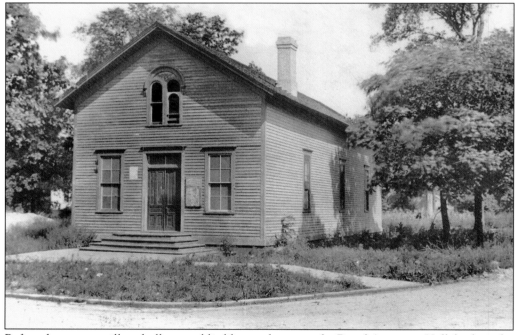

Before there was a village hall or a public library, there was the Royal Arcanum Hall, built in the early 1880s on the northeast corner of Wilmette and Central Avenues. This barnlike building served as a gathering place and the home of Wilmette's fledgling library in the 1890s. In 1905, with help from steel magnate Andrew Carnegie, the first free public library was opened at Park and Wilmette Avenues.

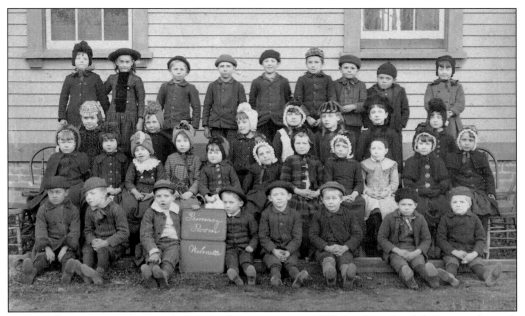

Miss Walker's Primary Room class poses for a portrait in 1890, by the side of the original wood-framed Central School at Central Avenue and Tenth Street, built in 1871. This building, Wilmette's first public school, was razed and replaced by an eight-classroom brick structure that opened in 1892.

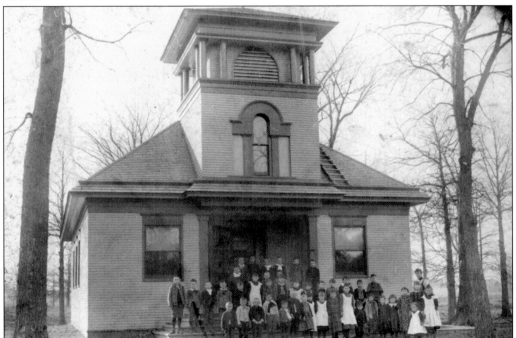

The first Logan School opened in 1893 in this one-room, frame building on Kline Street (later Prairie Avenue). The structure was later expanded to meet the needs of the village's growing number of schoolchildren. Today's McKenzie School is at about the same location.

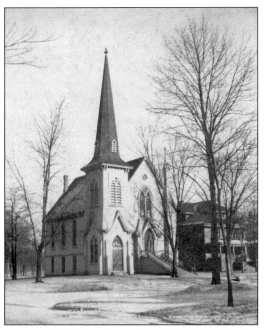

In 1875, Wilmette's Protestant denominations banded together as the Union Evangelical Church, erecting a building at the northeast corner of Wilmette Avenue and Lake Avenue. This comity did not last, however, as groups left to start their own churches. Wilmette Methodist Episcopal Church occupied the original frame building, shown here in 1906, until a larger brick one was built in 1908; the present structure dates from 1927.

Wilmette sported several social and literary clubs that met in members' houses in the 19th century. The Woman's Club began in this way in 1891 in the home of sisters Anna and Ida Law at Forest and Twelfth Streets. Another was the Sunday Evening Supper Club, shown here in about 1895. In the 20th century, the club would host such prominent speakers as William Jennings Bryan and Jane Addams.

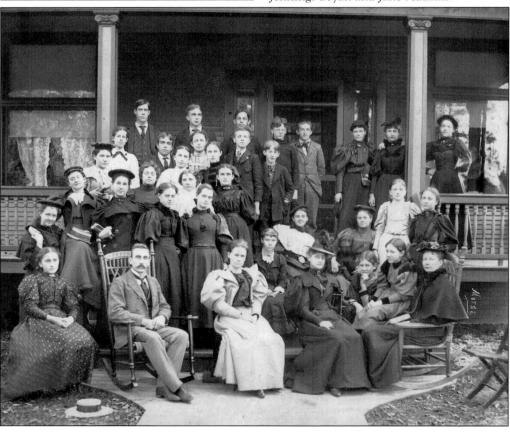

Two

GROSS POINT VILLAGE

The area now described as west Wilmette was once a separate town until its annexation in the 1920s. Settlers founded it in 1874 and called it the Village of Gross Point, possibly taking the name from Evanston's Grosse Point headland and 1873 lighthouse. Gross Point's borders were Ridge Road on the east, Locust Road on the west, Hill Road on the north, and Central Street, Evanston, on the south. Many of the founding families emigrated from the Trier region of Germany (then Prussia) and nearby Luxembourg to the United States, fleeing turbulent times in their homeland. Some came alone, but most arrived with other family members in the 1830s and 1840s. They were farmers, teachers, and skilled tradesmen with family names like Schaefer, Roemer, and Hoffmann. Determined to create a new community, they purchased farmland, built homes, established Wilmette's first church, and started businesses and organizations. They also brought their language and many of their German customs, notably saloons, beer gardens, and music. These immigrants were also involved in starting such local institutions as New Trier Township, naming it after their old hometown, and later New Trier High School. After over 150 years, many descendants of these early Gross Point families still reside in Wilmette—an amazing link to the past. Gross Point has not existed as a separate village for more than 90 years, but it lives on in the memories of its many descendants.

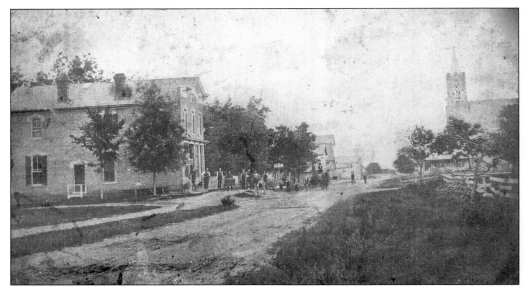

This 1870s photograph of Ridge Road shows a view north from Schiller Avenue. Ridge Road was Gross Point's eastern border and the center of its commercial activity. In the foreground, people are gathered at Schaefer's Saloon. Other commercial buildings are visible on the west side of the road. On the opposite side are a farm in the foreground and the steeple of St. Joseph Church in the distance.

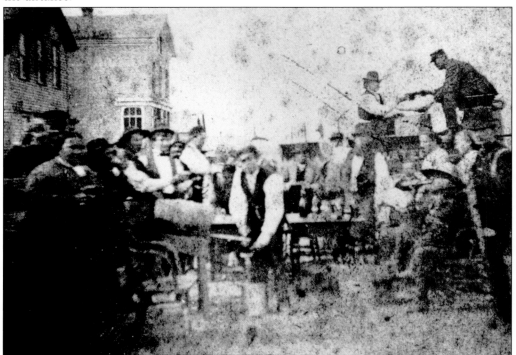

A crowd is gathered at the intersection of Ridge Road and Lake Avenue in this badly damaged 1860s photograph. The word *water* is partially visible on the wagon in the background, but it is unclear what occasion is bringing everyone together.

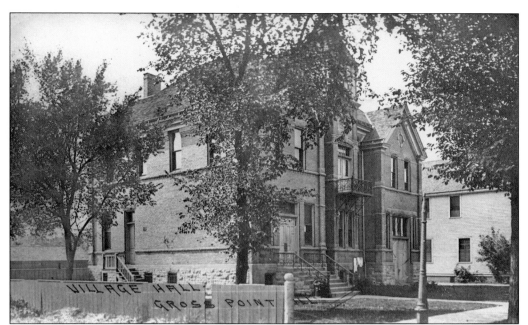

The Village of Gross Point built two village halls. The first one was a simple, one-story, wooden structure. The second, shown here, was much more elegant. It was constructed in 1896 by local tradesmen and was Gross Point's village hall until the town was dissolved in 1919. Original features included a balcony and a tower. In 1995, it became the home of the Wilmette Historical Museum.

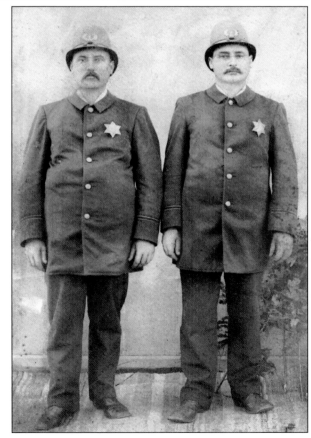

Gross Point had a small police force, headquartered in the basement of the Gross Point Village Hall. Peter Schaefgen (left) was the town's first police officer in 1886. Joseph Engels, his partner, joined the force in 1892. The station and four jail cells were in the basement of the 1896 village hall, and two cells are still on public view today as part of the Wilmette Historical Museum.

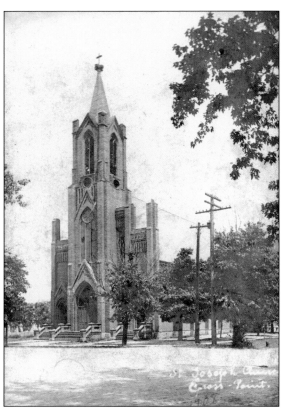

St. Joseph Roman Catholic Church was established in 1845, and it became a mainstay of the Gross Point community. The first three church buildings were located on the northeast corner of Lake Avenue and Ridge Road. The third building (shown here), constructed in 1868, was demolished after the current one was completed across the street in 1939.

This photograph of St. Joseph Cemetery was probably taken about 1895 to document a special occasion, such as Memorial Day. Consecrated in 1843, the cemetery was originally located next to the church before the church moved across the street. Many of the area's earliest settlers are buried here. St. Joseph's is one of the oldest cemeteries in the Chicago area.

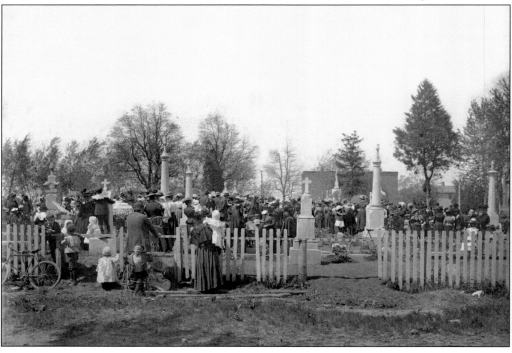

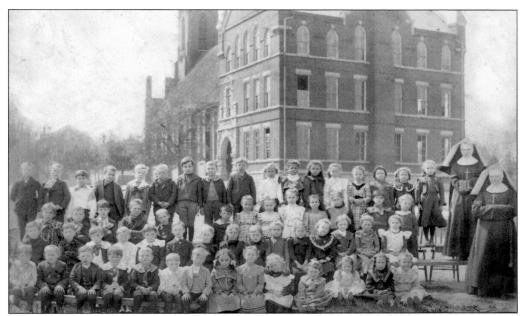

St. Joseph Church began a school in 1873, and in 1892, a new school building was added to the east side of the church, as pictured here. Many of Gross Point's children attended St. Joe's and were taught by nuns from Milwaukee's School Sisters of St. Francis. German was often spoken in the classrooms until World War I, when national anti-German sentiments forced the school to abandon the practice.

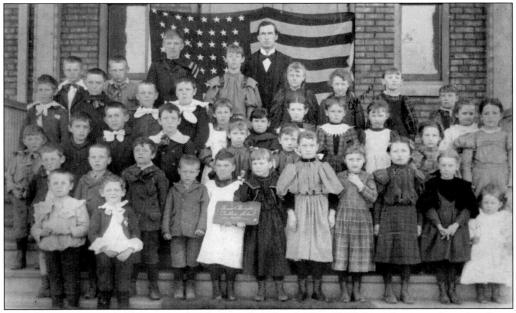

Not all Gross Point children attended St. Joseph School. This 1897 class photograph at the Gross Point Public School was taken shortly after the schoolhouse was built just west of Ridge Road on Wilmette Avenue on land that was donated by the Nanzig family. Originally a two-room, two-story, brick building, it was later remodeled and is now the home of American Legion Post 46.

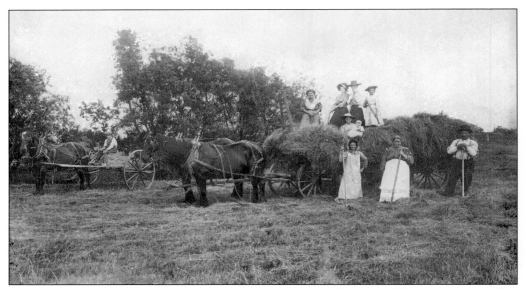

Most early Gross Point residents were farmers, working small farms of 100 acres or less. The Blum family is haying on their farm at Old Glenview Road and Wilmette Avenue in the summer of 1908.

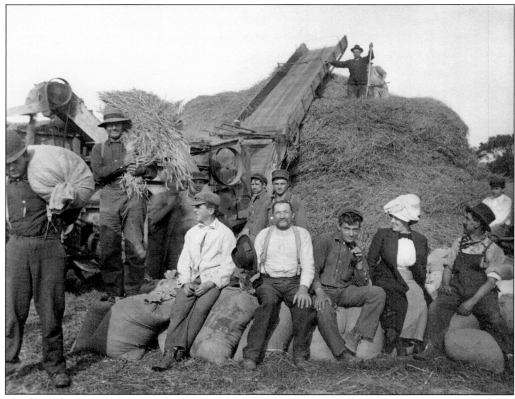

Neighbors helped each other out at threshing time in old Gross Point. Here, members of the Meier, Thalmann, Reinwald, and Blum families pitch in to help at the Braun farm on Illinois Road.

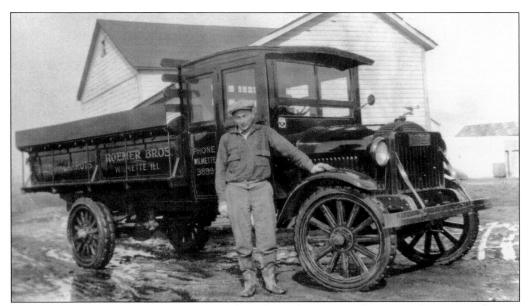

The local truck farming business dates back to the 19th century, when some Gross Point farmers carted their produce and flowers to Chicago's South Water Street Market with horse and wagon. This practice carried on for a century in some families, and motorized trucks gradually replaced horsepower. This Roemer Bros. truck is ready to be loaded at the family farm at 2608 Old Glenview Road.

The Michael Loutsch farm at Old Glenview and Hunter Roads was Wilmette's last working farm. Loutsch, born in 1882, is shown here on his farm in 1972, the year that Centennial Park opened on some of his former acreage. After his death in 1978, the Wilmette Park District acquired his remaining land, and the farm vanished.

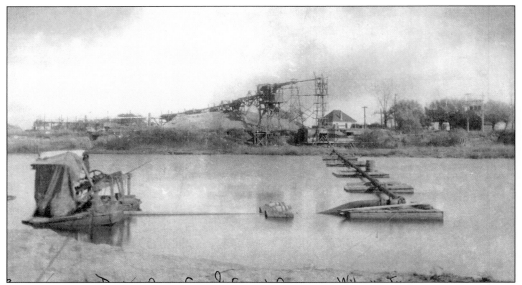

The Doetsch family established an excavating company in 1912 at the southeast end of Gross Point, fronting Ridge Road. Their property included a large sand and gravel pit, later known as Doetsch's Pit. Today, it is part of Lovelace Park in Evanston.

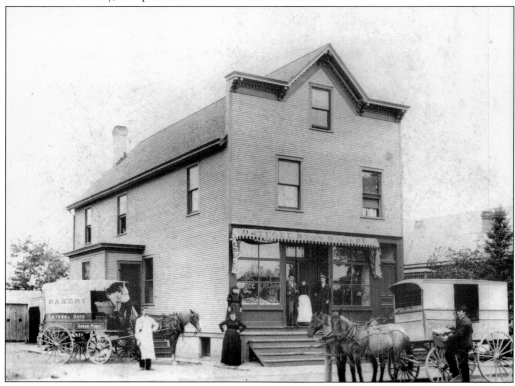

In 1894, brothers John and Frank Ortegel started Ortegel Brothers Bakery at 715 Ridge Road. John sold out to Frank in 1897. Frank and, later, his son carried on the business until 1921. The bakery building was torn down in the 1960s.

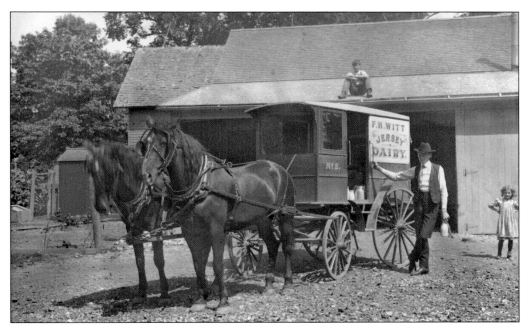

Among the many businesses in Gross Point was F.H. Witt Jersey Dairy. Witt began the dairy in east Wilmette in 1880. From 1895 to 1902, he rented barns for about 100 cows and five delivery wagons on the Peter M. Hoffman farm, located on Lake Avenue at Harms Road. The family also lived on the farm, and two of his children appear in this photograph—son Fred (on the roof) and daughter Anna. Later, the farm became the Wilmette Park District's golf course.

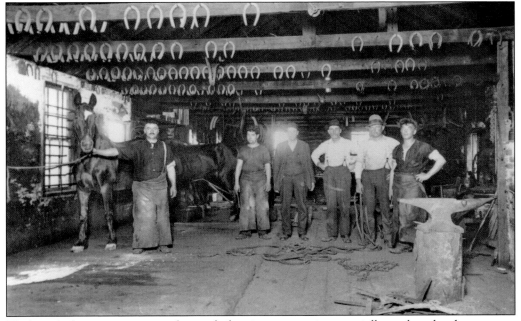

Blacksmith shops were an integral part of a farming community, especially one based on horsepower. This shop was owned by Martin Meier (far left, holding horse) and Christian Braun (far right). It was located on the south side of Lake Avenue, just west of Ridge Road.

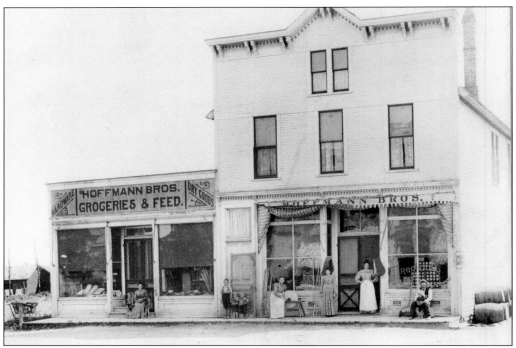

Brothers Philip and John Hoffmann established a general store in 1889 on the west side of Ridge Road, where they sold dry goods, hardware, hay and feed, groceries, and other essentials. Later, they opened a feed store across the street and built a new store on the northeast corner of Wilmette Avenue and Ridge Road. The brothers also founded the lumberyard near downtown.

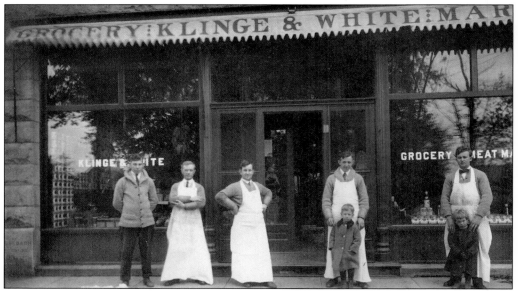

William Klinge and brother-in-law George White opened their grocery store in 1908, moving it to this location at 821 Ridge in 1910. Here, it remained in business until White's retirement in 1950. Pictured in about 1915, from left to right, are Jim Schaefgen, Joe Rau, White, Harry Leis, and Klinge. The boys are Ralph (left) and Arthur Klinge.

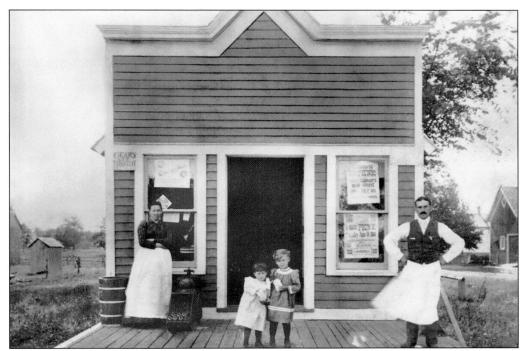

In 1900, the Gross Point Post Office, located at the southwest corner of Ridge Road and Schiller Avenue, was also a general store. Residents came here to collect their mail, as there was no home delivery. The postmistress at the time was Leftilda Hoffmann Schaefer (on left), posing here with her daughters Vera (left) and Florence, and storekeeper Harry Spies.

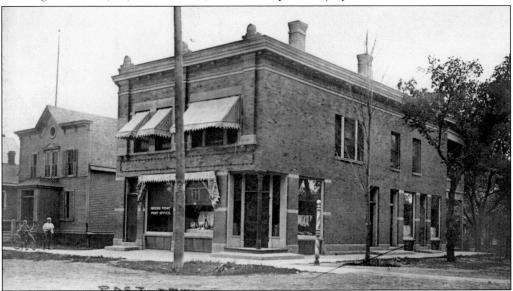

Owned for about a century by the Bleser family, this building at the southwest corner of Ridge Road and Schiller Avenue was constructed in about 1907 to replace the older post office, pictured above. It also housed a barbershop for many years. Later additions expanded the building to the south and west, including a popular bowling alley.

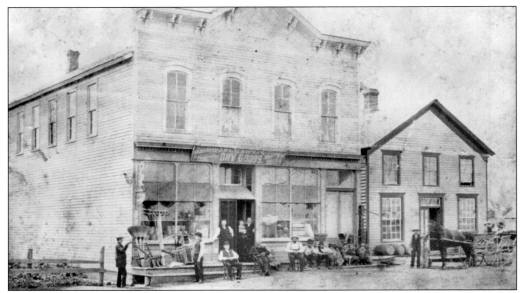

Lauermann's Tavern and Hotel, established in the 1840s, was one of the area's earliest businesses. Originally, the smaller building on the right was a tavern and wayside inn for travelers. The family added a dry goods store (at left) in the later 1800s. Lauermann's was located on the west side of Ridge Road near Forest Avenue, on property that later became part of Mallinckrodt Convent.

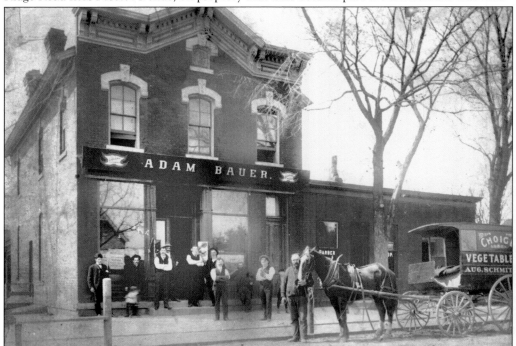

At least 15 local families were in the saloon business in Gross Point. For a community of 500 residents, this was a major industry. John Schaefer built this impressive, Italianate-style saloon in the 1870s, and Adam Bauer, his son-in-law, took it over in the early 1900s. This building, missing its elaborate cornice, still stands at the northwest corner of Ridge Road and Schiller Avenue.

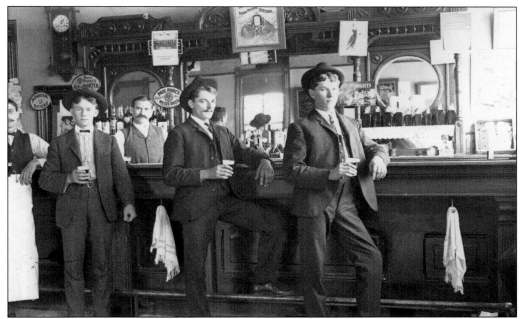

In 1903, a man could join his friends for a beer at Schallick's saloon at the southwest corner of Ridge Road and Wilmette Avenue. From left to right are Frank Meier, William Klinge, Bill Rengel (barkeep), Mike Loutsch, and John Loutsch. The saloons were constantly under fire from temperance organizations and dry communities, like Wilmette, that tried to shut them down.

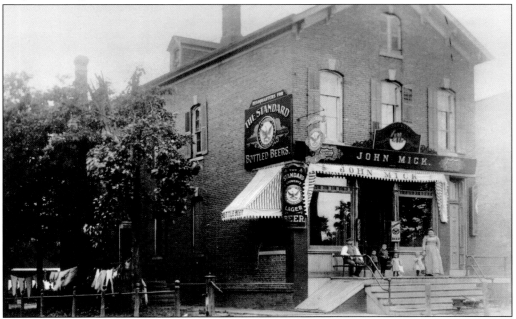

One could enjoy a glass of Standard lager beer at John Mick's tavern on the northwest corner of Ridge Road and Lake Avenue. On the porch are John and Dora Mick and their family in about 1898. As was common at the time, the Micks lived above the business. Mick remodeled this exterior in 1907, connecting it with a new store next door that was owned by his sister and her husband.

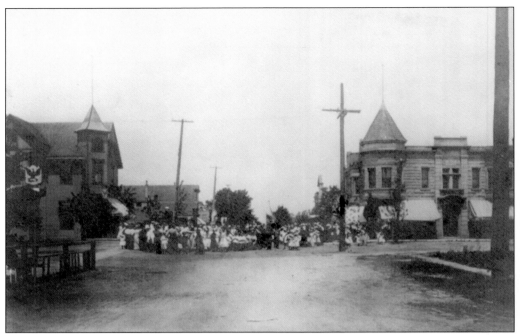

The majority of Gross Pointers were Roman Catholic, and celebrations like this early-1900s Corpus Christi procession were part of community life. This annual parade of the sacred host proceeded down Ridge Road from St. Joseph Church. At the corner of Ridge and Wilmette Avenue, one can see two taverns on the left and the Hoffmann Bros. store (built in 1900, burned down 1909) on the right.

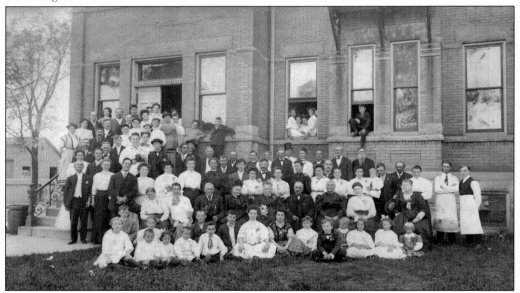

Family life was part of the rhythm of life in the village, and many people had large families. John and Mary Felke and their relatives celebrate their 50th wedding anniversary in this 1908 photograph at the Gross Point Village Hall. The Felkes had a substantial greenhouse business in Wilmette.

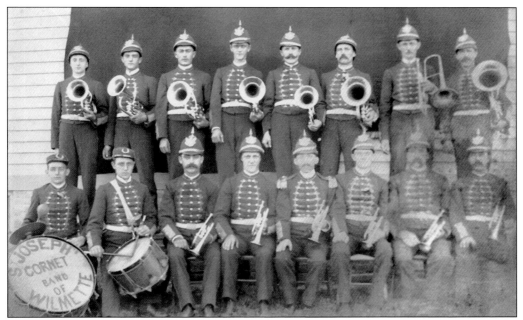

Music was integral to Gross Point life and German American culture in the 19th century. The St. Joseph Cornet Band has a very Teutonic look in this 1889 photograph. From left to right are (first row) Billy Vogelsang, Tony Felke, Anton Schneider, Joe Luediger, Joe Arns, Joe Heurter, Maurice Colbert, and Pete Schaefgen; (second row) Edward Zeutschel, Adam Braun, Joe Bleser, Math Bauer, John Steiner, Joe Schaefgen, Pete Abbink, and Math Keil.

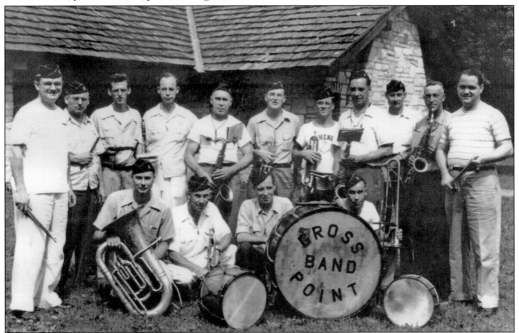

The St. Joseph Cornet Band later became known as the Gross Point Band, seen here in 1947. It was also informally known as the Schneider Band because so many Schneiders were members.

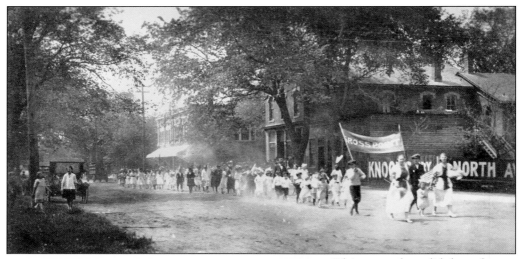

This unusual candid shot of a parade on Ridge Road was taken in about 1919 by local resident Robert J. Hoffmann, a veteran of World War I.

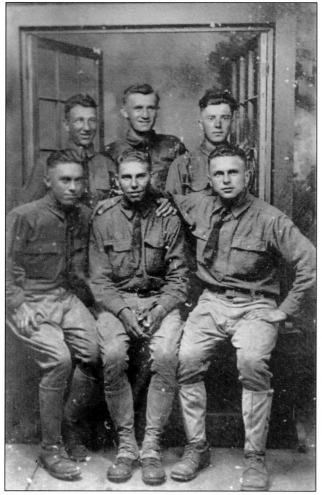

Despite anti-German feeling in the United States during World War I, many German Americans served. Among the World War I draftees from Gross Point are, from left to right, (seated) Peter Heurter, James Schaefgen, and Joseph Meier; (standing) Matt Heinzen, Joseph Engels, and Anton Borre. Heurter died from Spanish influenza during the war, and Wilmette's American Legion post is named in his memory.

Three

ROADS AND RAILS

The earliest transportation system along the North Shore was the network of paths connecting Native American villages to waterways and to one another. Some later roads, such as Old Glenview Road, Ridge Road, and Wilmette Avenue, followed these ancient routes. In 1832, the federal government established the Green Bay Trail, which linked Fort Dearborn in Chicago to Fort Howard in Green Bay, Wisconsin. In Wilmette, that trail closely followed the lakeshore.

In 1855, the first railway line was completed through town. First known as the Chicago and Milwaukee Railroad, later the Chicago & North Western Railway, and then Metra–Union Pacific line, this train has offered both passenger and freight service. Because it was a prosperous route, another railway company sought to build a competing line north from the city. In 1889, the Chicago, Milwaukee & and St. Paul Railway completed tracks to Wilmette and a depot at Third and Maple Streets, hoping to continue northward at a later date. The extension never materialized, and the line stopped passenger service in 1908.

Two electric train lines also served the community. In 1899, the North Shore Line began operating through Wilmette. It became a very popular service because it carried people between Chicago and Milwaukee, stopping frequently between the two cities. Local people also rode it to downtown Wilmette, Ravinia, and New Trier High School. Car travel began to edge out public transportation after World War II, especially after the coming of expressways like the new Edens Superhighway. The North Shore Line was forced to shut down in 1955. The other electric line, the "L," first extended its operation to Wilmette in 1912 and still serves the village today.

Early Wilmette roadways, including the brick streets, were designed for travel by horse. Here, Meise Vanderkloot is pulling out of her driveway at Lake Avenue near Sheridan Road. Many local homes at the time had barns and carriage houses for horses and buggies.

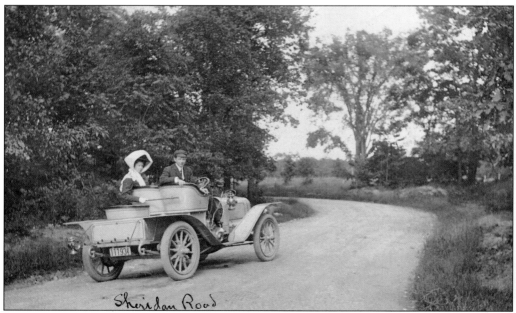

Sheridan Road was the area's most popular avenue for pleasure driving in the early 1900s. This couple has stopped near Chestnut Avenue. The posted speed limit at the time was a zippy 12 miles per hour.

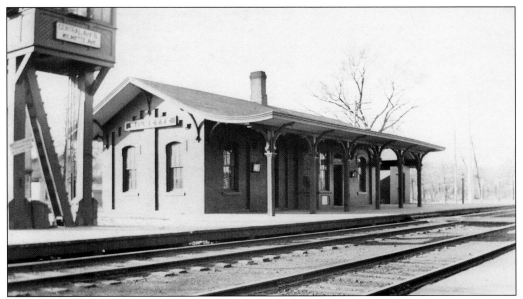

The Chicago & North Western Railway began to offer scheduled service to Wilmette riders in 1869. The station pictured here was built in 1874. By the early 1890s, the railroad had installed two sets of tracks, one inbound and one outbound, to handle increased passenger and freight traffic and a watchtower to monitor it all.

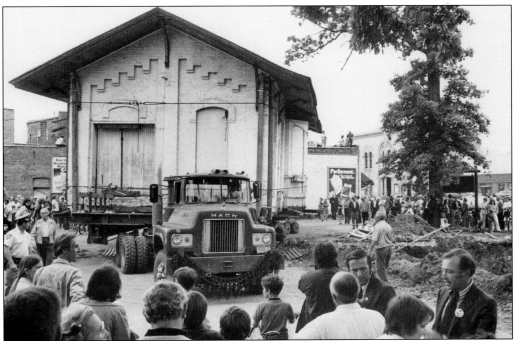

A century after the 1874 depot was constructed, the railroad slated it for demolition. The Wilmette Historical Society led a campaign to save the old station, moving it to 1139 Wilmette Avenue, about a block east of its original location. A celebratory crowd of 2,000 came out to watch the move. The depot is designated a Local Landmark and in the National Register of Historic Places.

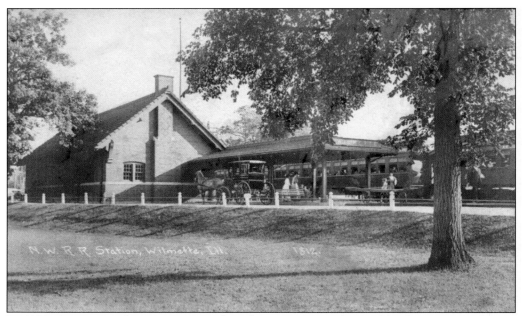

By 1898, the existing depot was too small, and a new one was designed by the eminent Chicago firm of Frost & Granger, architects of more than 200 Midwest railway stations. With its redbrick exterior enhanced by stone detailing and a tile roof, the depot was a handsome addition to the downtown area. The 1874 station was moved one block north along the tracks and used for freight storage.

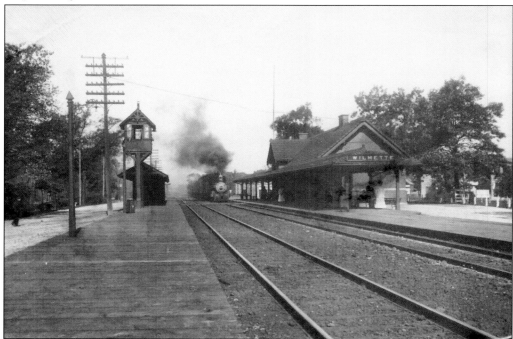

A train billowing smoke was a familiar sight to commuters in the early 1900s. Many people are waiting at the Wilmette station, which was located near Wilmette Avenue.

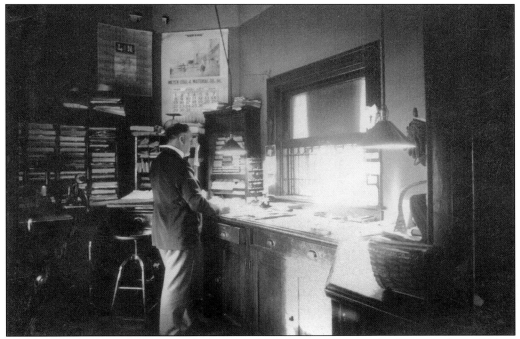

Earl Orner (shown in his depot office) was Wilmette's station agent for 50 years, from 1902 to 1952. Probably the most visible and widely known person in Wilmette during that period, Orner was elected village president and served from 1925 to 1931.

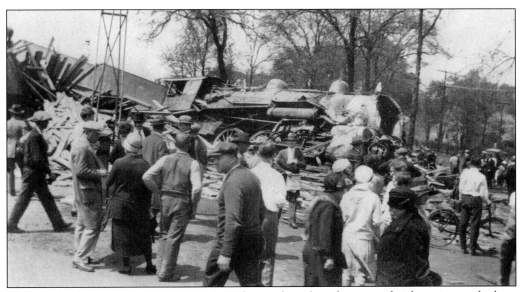

Train crashes have never been common in Wilmette, but when there were freight trains on the line, traffic patterns were more complicated. On May 21, 1926, this Chicago-bound express passenger train plowed into the rear of a standing freight train just north of Lake Avenue, demolishing four freight cars filled with lumber before leaving the tracks and overturning. The sound of escaping steam brought hundreds of onlookers. Amazingly, no one was seriously injured.

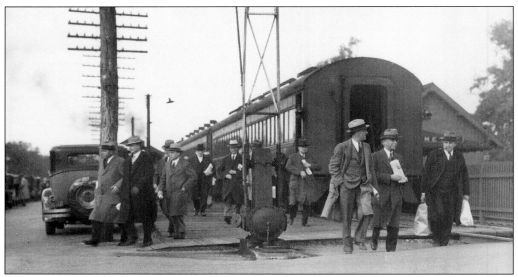

Commuters disembarking from the train have been a familiar village sight for more than a century. These 1931 businessmen are probably hurrying home to dinner. Note that there is not a bare head in sight.

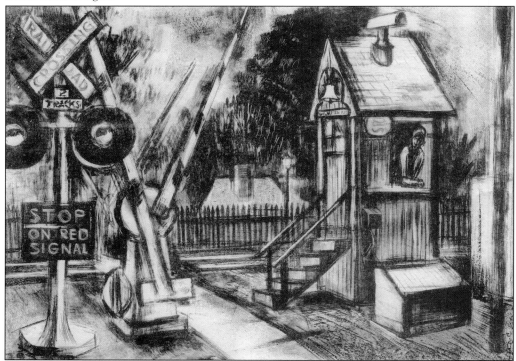

This 1940s lithograph by Wilmette artist Marian Witt depicts the gateman's shack at Wilmette Avenue. Gatemen's shanties at street crossings were once familiar features of the village landscape. The gateman, often a disabled employee who had previously worked for the railroad in other capacities, manually raised and lowered the pneumatic gates every time a train came through. Automatic gates later replaced the gatemen.

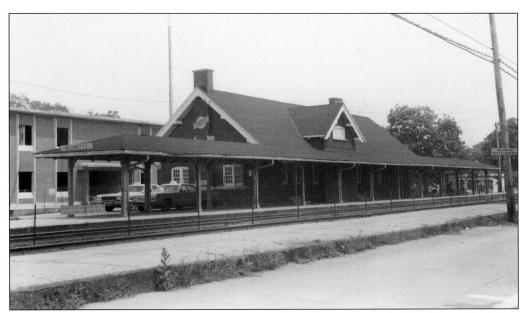

In the mid-1970s, village government decided to replace the aging town hall with a new building, seen here under construction in the background. The 1898 train station, in the foreground, was razed to make way for a parking lot for the new village hall. A new depot was built one block north at Central Avenue.

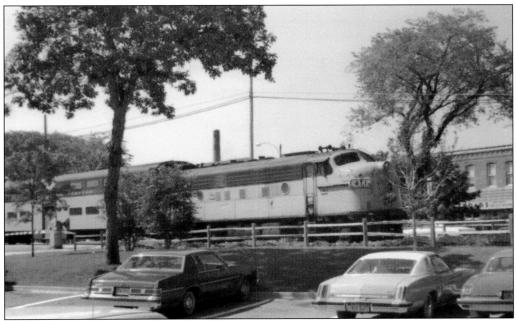

The two-tone, bright yellow and forest green, commuter trains were a common sight in the mid-20th century. The train in this 1979 photograph is actually traveling south (to the left in the picture), pushed by the streamline locomotive. This innovative push-pull commuter system, pioneered by Chicago & North Western in 1960, allowed the engine to remain at the same end of the train for both inbound and outbound trips.

NIGHT RAID PUTS "L" IN WILMETTE

Northwestern Works Gang of Men Under Cover of Darkness; Extends Spur.

DEPOT UP BY MORNING.

Trains Run All Day; Residents Opposed Extension; Feared Summer Picnic Parties.

The Northwestern Elevated Company played an April Fool's Day joke on the Village of Wilmette in 1912. Without permission from the village board, the company laid track into town from Evanston and set up a passenger platform and ticket shanty. Commuters awoke the following morning to find "L" trains in town, ready to take them into Chicago's Loop. The board protested the move but ultimately lost the battle.

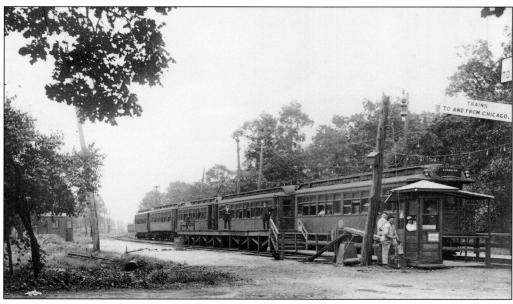

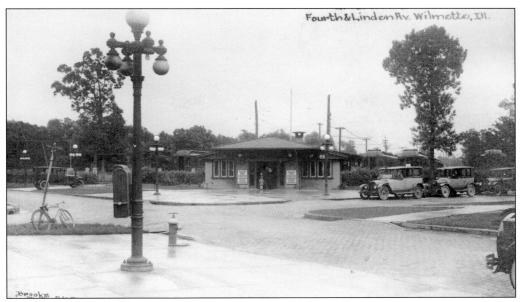

In 1913, a one-room "L" station was constructed, designed by railroad company architect Arthur U. Gerber. In 1921, two wings were added to enlarge the original building, as shown in this 1924 view of Fourth Street and Linden Avenue. This Prairie-style station was replaced in 1993, but it has been restored and preserved as a local landmark and is listed in the National Register of Historic Places.

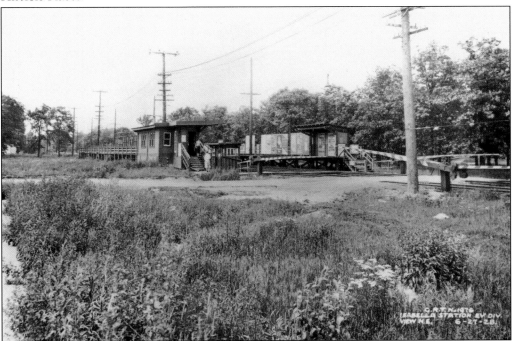

Wilmette originally had two "L" stops, one at Linden Avenue and one at Isabella Street. The Isabella station operated from about 1913 to 1973. When this photograph was taken in 1928, vacant land surrounded the Isabella station.

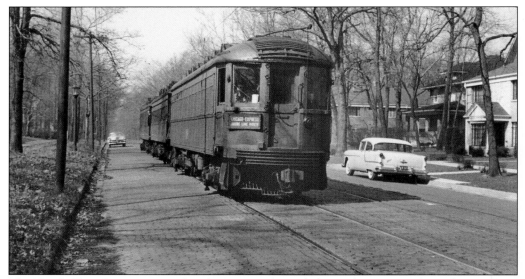

The North Shore Line originated in the Loop and traveled over the same tracks as the "L" trains as far as southeast Wilmette. There, the North Shore cars headed west down Greenleaf Avenue. Greenleaf is wider than most Wilmette residential streets because it was the trolley's route to downtown. The train made poor time on Greenleaf because it stopped to pick up passengers and competed with automobile traffic.

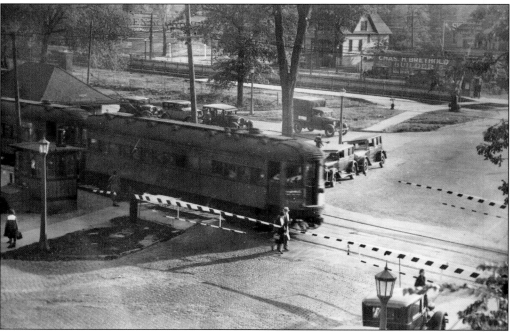

Once the North Shore Line reached the curve near Poplar Drive and Greenleaf Avenue, it paralleled the steam commuter line as seen in this photograph taken at the Wilmette Avenue crossing in 1931. The roof of its downtown station is visible behind the train. Automobiles sometimes had to wait at two sets of gates for both the interurban streetcar and the commuter train to pass before crossing the tracks.

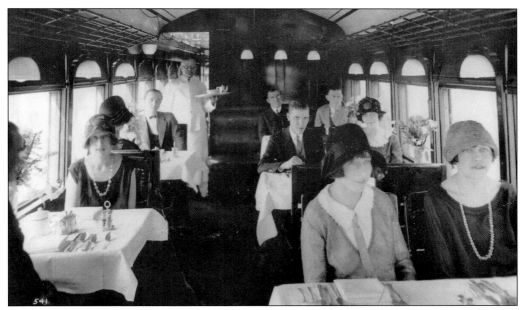

Until 1949, the North Shore Line had full dining car service on many trains between Chicago and Milwaukee. These cars were lavishly appointed with plush armchairs and mahogany dining tables, and staffed by experienced chefs and waiters. Lee Abegg of Wilmette (on the right, middle) and his friends are enjoying this dining car in the 1920s.

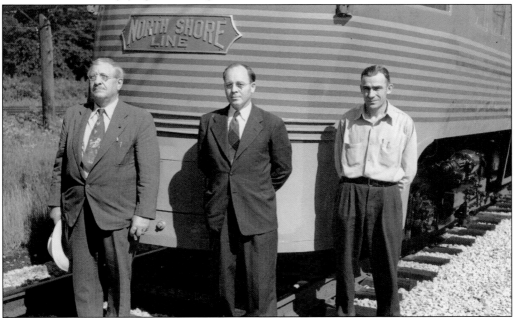

The Skokie Valley route of the North Shore Line ran through west Wilmette, with a station in nearby Glenview. Between 1926 and 1963, these streamlined trains, called electroliners, carried commuters. Standing in front of one of these engines are employees, from left to right, Henry Cordell, master mechanic for the railway, Ken Wilkins, and Frank Beschack. Cordell lived on Wilmette's Greenleaf Avenue and was sometimes called out of his house to repair a nearby trolley.

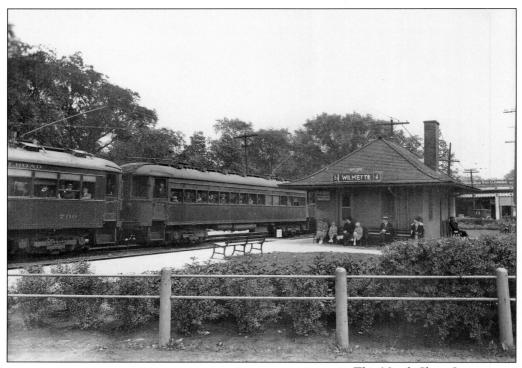

This North Shore Line station, located just south of Wilmette Avenue, is shown in 1925 just as a packed train is pulling into the station. Notice the Greenleaf building in the background, with its distinctive terra-cotta exterior and a sign for Kashian Bros. Rug Cleaners on its roof.

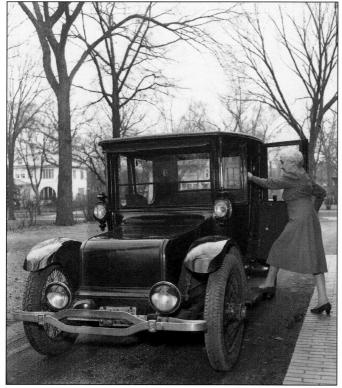

In this 1941 photograph, Bessie DeBerard of 1220 Greenwood Avenue gets ready to take a drive in her 1926 Detroit Electric automobile. Electric cars were particularly favored by women, who appreciated how comparatively easy they were to start and how smoothly and quietly they ran. By the 1930s, however, done in by cheap gasoline, they had become a rarity.

Four

GOVERNMENT AT WORK

Wilmette residents today take for granted the infrastructure of paved streets, street lighting, clean water, sewer system, fire and police protection, public transportation, garbage collection, and everything else that goes into the functioning of a modern community. The main focus of local government is the maintenance and enhancement of all of these services. For the founding generation of the 1870s, however, almost the whole of this supportive network had yet to be built—an expensive, laborious, and sometimes controversial process that required decades to complete.

Once Wilmette had decided, by the referendum of 1894, not to allow itself to be absorbed into the older and much larger town of Evanston to the south, local improvement proceeded more vigorously than before. The dirt streets, which turned into rivers of mud in the spring and yielded clouds of dust in the summer, had almost all been paved with brick by the late teens of the new century, and a system of electrical street lighting soon followed. Public-spirited citizens strove to bring public schools, parks, and a free library to a steadily expanding community. The professionalization of fire and police protection meant a move from early reliance on volunteers and part-timers to the creation of highly trained and well-equipped modern departments.

More government meant, inevitably, more regulation of residents' public behavior, as the number and variety of local ordinances expanded exponentially to cover everything from coarse language and signage to animal control and, most crucially, the kinds of structures that could be built and where. In 1922, the local planning commission created the first of many plans in an attempt to control the direction and development of the village's growth. Elections have often turned on issues of regulation and property rights, sometimes involving different visions of what kind of community Wilmette can and should be.

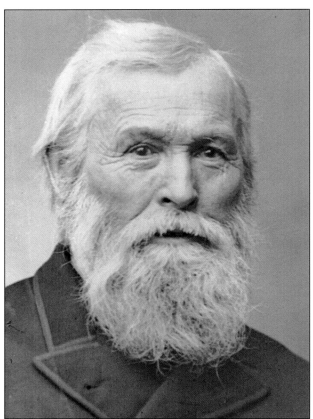

John G. Westerfield (1823–1894), Wilmette's first president, arrived from Yonkers, New York, in the 1850s to farm a 200-acre tract near the lakeshore. For several years, he also operated a pickle factory at the corner of Lake Avenue and Sheridan Road. In a meeting at Andrew Sherman's house on Greenleaf Avenue on November 8, 1872, he was chosen president on the seventh ballot. A surveyor, Westerfield laid out the village's first streets.

Wilmette's first village hall was a modest frame structure erected in 1890 on a triangle of land purchased from absentee investor Henry Dingee, bordered by Central Avenue, Wilmette Avenue, and the railroad tracks. When Wilmette decided to build a new hall in 1910, this one was bought by local businessman A.C. Wolff, who moved it to 625 Park Avenue, where it remains today as a private residence.

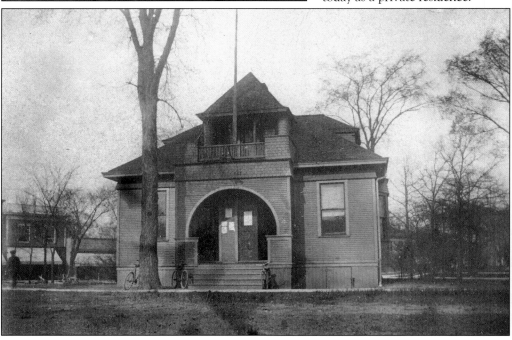

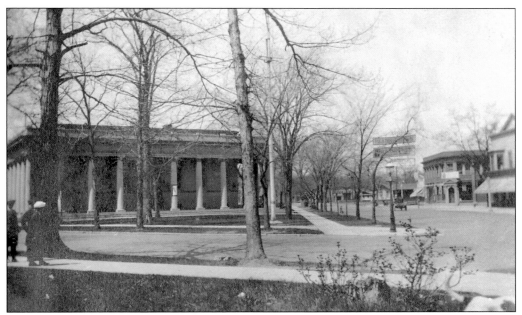

Erected in 1910, this distinctively colonnaded stone-and-brick village hall, shown here in 1918, was intended to serve the expanding needs of a community that had grown from 1,500 to 5,000 residents in the space of 20 years. Partially rebuilt after being damaged in the Palm Sunday tornado of 1920, the building continued to house Wilmette's government until replaced by the current village hall in 1976.

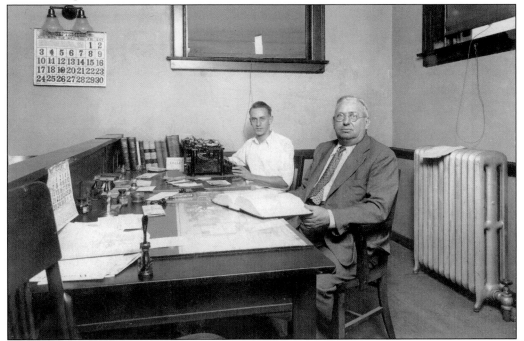

Judge John Peters, police magistrate of Wilmette, and his son Harry, the court clerk, are shown at work in their office on the second floor of the village hall in 1933.

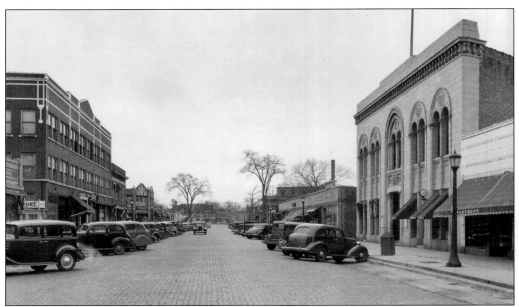

This view of downtown, looking west on Wilmette Avenue in 1937, shows the brick paving so typical of Wilmette's streets east of Ridge Road. Wilmette began paving its streets with specially made bricks in the 1890s, but by the 1920s, cheaper, smoother synthetic asphalt had become the standard. Yet many people prefer brick paving in residential areas, and the village still has some 14 miles of brick streets.

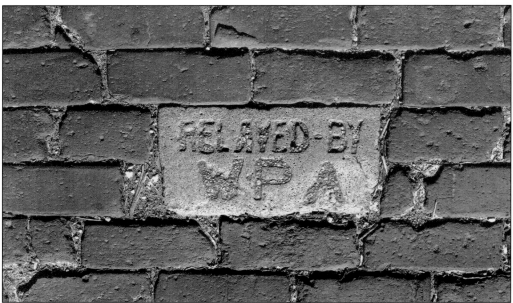

In the middle of the Great Depression, the federal government's Works Progress Administration (WPA) put hundreds of unemployed men to work on Wilmette's streets: bricks were removed, a fresh layer of sand put down, and each brick put back again with its bottom, unworn edge facing up. The men left handmade cement markers, like this one on Forest Avenue, embedded among the bricks as reminders of their hard work.

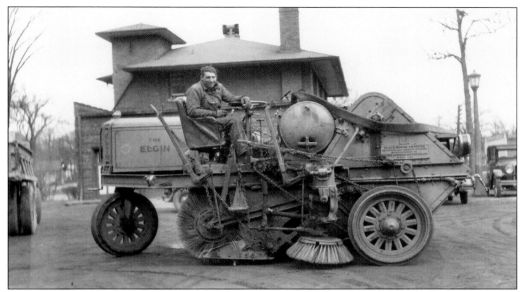

The Wilmette Public Works Department, established in 1895, is responsible for maintaining streets, sewers, and much else to do with the infrastructure of the village. This 1930s photograph of the Village of Wilmette's Elgin model street sweeper was taken at the Village Yard, then located in the 800 block of Green Bay Road, behind the fire station.

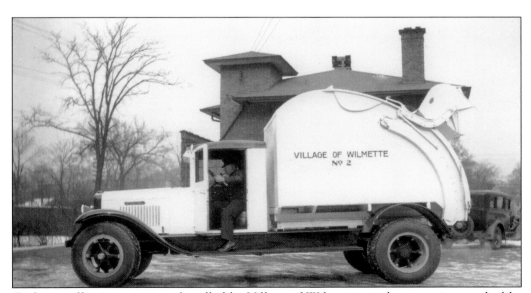

Garbage collection was once handled by Village of Wilmette employees, using trucks like this 1930s model. Like many other services, garbage collection is now done under contract by private companies.

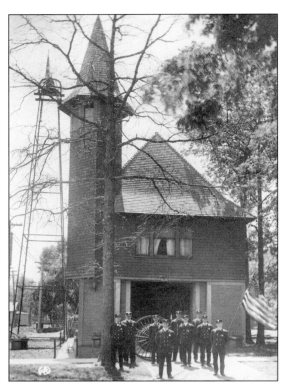

Volunteer firefighters pose with their hose cart in front of the first firehouse at 1231 Central Avenue in about 1903. The tall tower was designed for air-drying the fire hoses after use.

Firemen in 1916 show off the village's first motorized hook-and-ladder truck in front of the Village Theatre, a silent movie theater later known as the Baker Building, at 1150 Wilmette Avenue. From left to right are A.C. Wolff, William Herbon, A.E. Wolff, unidentified, Martin Kalmes, George Neithaver, Walter Zibble (at wheel), and unidentified.

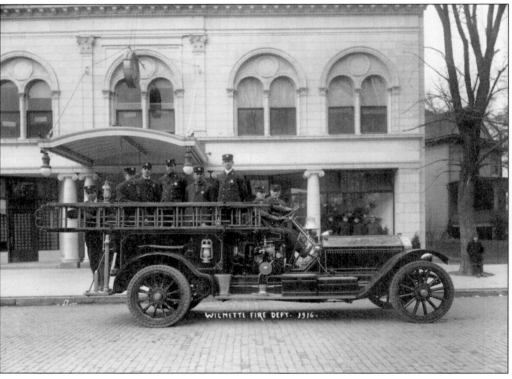

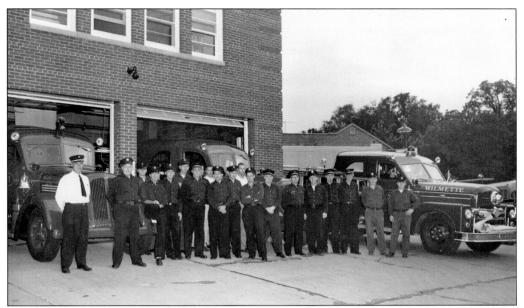

Fire Chief Fred Behrendt (at left) stands in front of the station on Green Bay Road in 1958 with firemen, from left to right, Robert Ortegel, Elmer Mortensen, Gordon Roeder, Tom Schinler, Albert Krueger, Herman Zibble, Bill Downs, Earl Bondy, Ralph Borre, Bernie Thalmann, Robert Winter, Harold Herbon, Robert Brady, Jim Feeley, Cliff Johnsen, Jack Lindstrom, Jerry Schwartz, and Jim Schneider. The fire engine at far right had been purchased earlier that year.

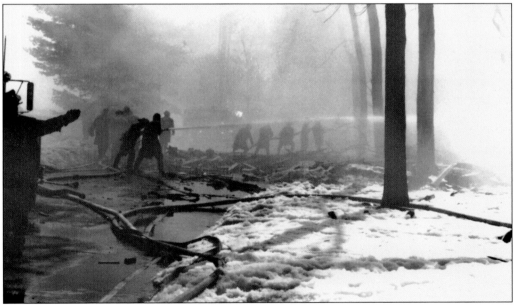

On St. Patrick's Day 1978, the Wilmette Fire Department responded to a report of a fire at 1221 Cleveland Street. No sooner had they reached the house than it exploded, injuring several firefighters and severely burning the homeowner, who later died of his injuries. This photograph shows Wilmette firefighters battling the blaze. Authorities soon learned that the owner had been operating a commercial fireworks factory in his basement.

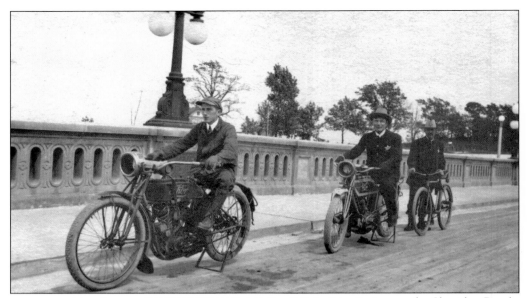

Posing on the Sheridan Road bridge with their motorcycles in about 1915, two Wilmette policemen join longtime police chief Edward G. Sieber, with bicycle. Before motorized vehicles were available for the purpose, the police patrolled the village on foot and by bicycle.

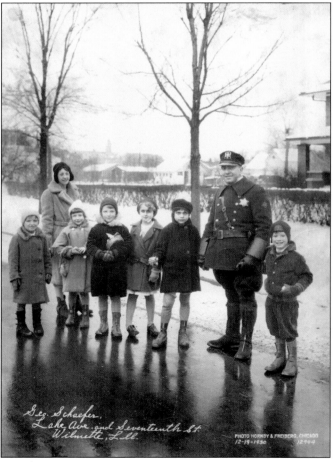

Community outreach has always been a part of the police department's mission. Here, officer George Schaefer poses with schoolchildren in December 1930 at Lake Avenue and Seventeenth Street.

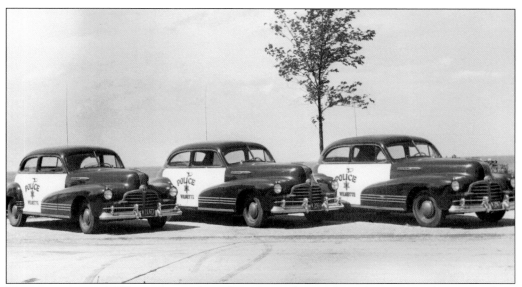

The appearance of Wilmette's squad cars has changed a number of times over the years—from the look of this 1940s fleet, to a yellow color scheme in the 1970s and 1980s that few officers remember fondly, to white cars with a blue stripe along the side. Coinciding with the department's 125th anniversary in 2011, the cars were returned to a more traditional black-and-white.

Major crimes have been mercifully rare in Wilmette. On the morning of February 10, 1956, a trio of robbers held up the First Federal Savings and Loan at 1151 Wilmette Avenue, downtown, and made off with $4,300. They were captured by police a mere six minutes later near the intersection of Sheridan Road and Tenth Street. This photograph shows patrolman Edward Eggert of Kenilworth (left) making the arrest, assisted by officers Frank Fall and Richard Yohe of the Wilmette force.

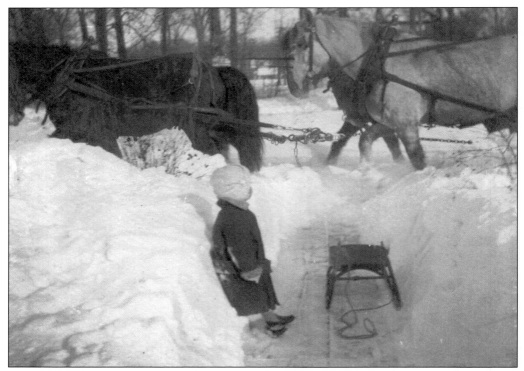

Clearing the streets of snow has been a responsibility of village government since the days of horse-drawn snowplows. In this 1918 photograph, taken after the big blizzard that winter, two-year-old Fred Aschbacher watches the fire department's horses pull a plow.

Wilmette has always been proud of its trees, and particularly its lovely elms, shown here forming a canopy over Greenwood Avenue, west of Twenty-first Street, in 1980. The Village of Wilmette has been battling Dutch elm disease since the 1950s and in recent years has moved aggressively to limit damage caused by the emerald ash borer.

Prominent Wilmette citizens gather for the opening of the Water Plant on January 27, 1934, as the daughter of Village President Carbon Petroleum Dubbs prepares to throw the switch. Wilmette had been purchasing its water from Evanston since 1892, but Dubbs was determined that the village should have its own waterworks, and he strove hard to gather the necessary funds. By 1938, Wilmette was selling water to Glenview.

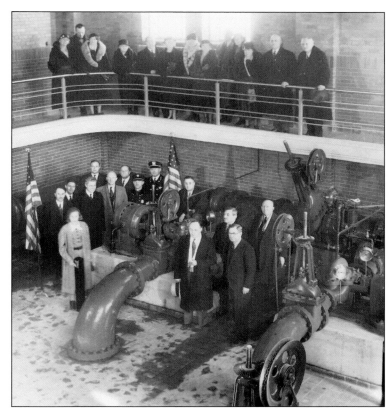

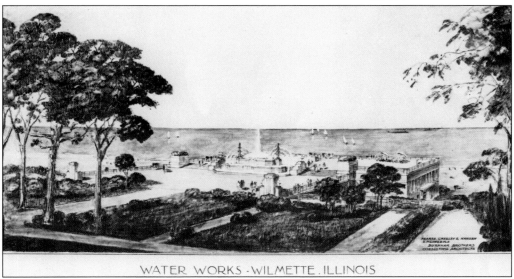

WATER WORKS · WILMETTE · ILLINOIS

The Art Deco–style pavilion on the roof of the waterworks, shown in this 1930s drawing, was originally created to soften the plant's appearance. It included water fountains, plantings, lounge chairs, and ornamental lighting. Free symphony concerts were held on the esplanade (as it was called) beginning in 1935. The concerts eventually moved to Wallace Bowl, and the esplanade had to be removed when major roof repairs became necessary.

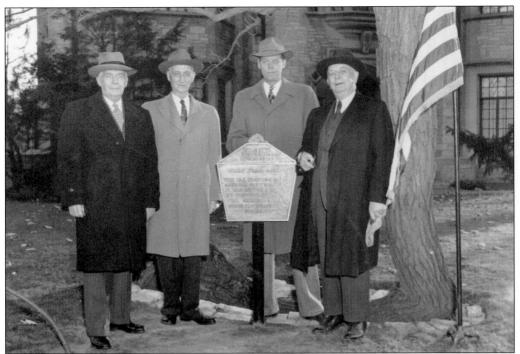

The Wilmette Historical Museum of today is descended from the Wilmette Historical Commission, organized in 1948 as a branch of village government. One of the commission's first projects was to place bronze markers beside local trail trees. Shown here dedicating a plaque at Canterbury Court are, from left to right, James Kline, Horace Holley, William Wolff, and Herbert Mulford.

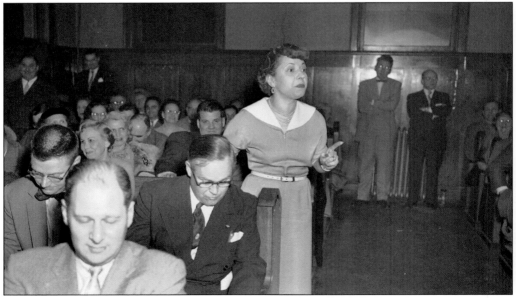

Zoning issues have often stirred controversy in Wilmette. At a packed meeting of the zoning commission at the village hall in 1956, Antonia Rago Herbert, a local attorney, speaks out against a proposal to allow a motel to be built on Sheridan Road in No Man's Land.

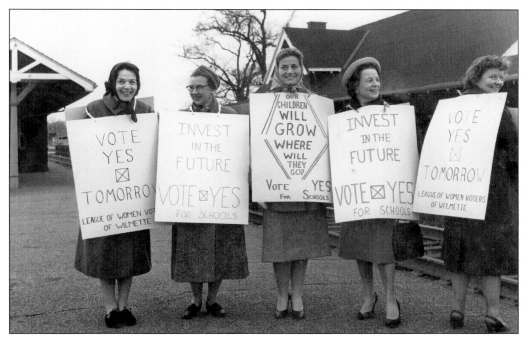

The League of Women Voters has been active in Wilmette since 1924. Here, League members lobby commuters at the Chicago & North Western train station in 1961. From left to right are Muriel Cohen, unidentified, Laverne Gobble, Mary Gerden, and Jean Bonynge.

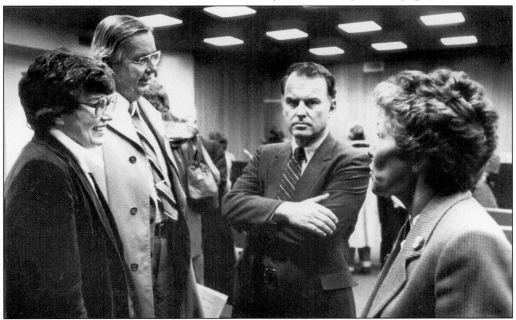

Elections have often been lively affairs in the village. In this photograph from Election Day 1983, newly elected Village Trustee Mimi Ryan (at left) and her husband, John Ryan, confer with Village President Vernon Squires and Trustee Ann Wollan. In 1985, Wollan ran against Squires, who was reelected to another four-year term as president.

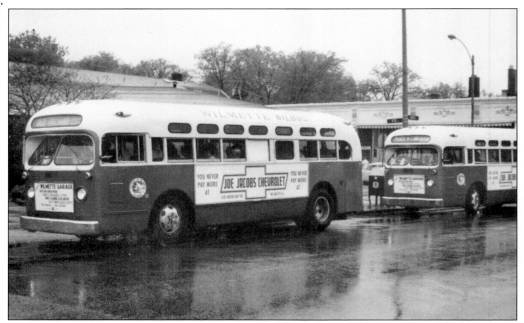

Wilmette once operated its own bus system, called "Wilbus." In 1974, the Village of Wilmette purchased six 15-year-old buses from Lexington, Kentucky, to make up the Wilbus fleet; two of those can be seen here in front of the CTA station at Fourth Street and Linden Avenue. By the time Pace took over in 1995, the fleet had been thoroughly modernized and expanded to 15.

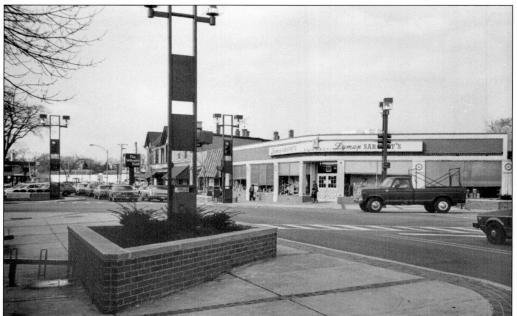

Downtown Wilmette has changed very little over the past century, but improvements have occasionally been attempted, from installing—then later removing—parking meters to redesigning streetlights and sidewalks. This 1979 view, looking west on Central Avenue from the southeast corner with Wilmette Avenue, shows one such renovation, with planters and lights.

Five

DOING BUSINESS

People have been doing business in Wilmette for over 150 years, beginning with the agricultural trades of the 1830s. Yet the scale of commercial life in the community, like the village itself, remained small for many years. The typical Wilmette business was a family shop, operated out of a modest storefront with family apartments on the second floor. The first businesses grew up along the 600 block of Green Bay Road, across from the original train depot, which at that time was west of the railroad tracks. After the building of a village hall in 1890 and a new depot in 1897, a "downtown" business area east of the tracks began to grow.

As the boom years of the 1920s swept through Wilmette, downtown expanded and new shopping districts sprang up at Fourth Street and Linden Avenue and at what is now Plaza del Lago. The next big changes followed World War II, as new housing replaced the family farms of old Gross Point and the advent of a superhighway in the 1950s made the shopping center at Edens Plaza possible, with its large chain stores.

Despite all of these changes, many Wilmette businesses have shown remarkable staying power. From one generation to the next, they have shaped the experiences of day-to-day life here in ways large and small. To have grown up in the village or to have lived here for many years is to treasure vivid memories of favorite local shops and eateries and of the people who have worked in them. The experience of life in Wilmette over the generations is inseparable from the history of its business community.

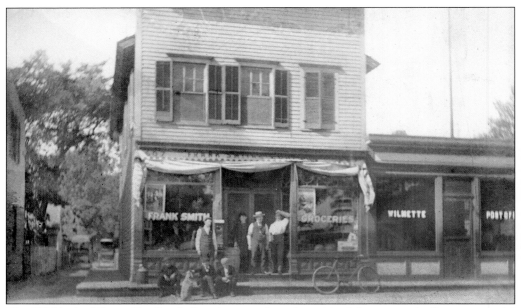

The 600 block of Green Bay Road, directly across from the original depot, was the first commercial district in Wilmette. The first general store was begun by W.H. Kinney in the early 1870s. When Kinney died in 1895, Frank Smith took over. This photograph shows the storefront in about 1910. In 1953, someone bought the old building and moved it to Evanston, where it remains as a private residence.

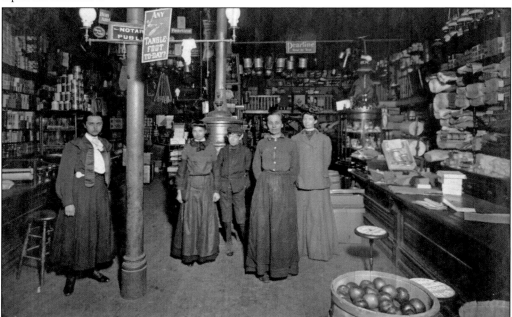

Women shared the work of family businesses like Mueller's general store. This interior photograph from about 1906 shows, from left to right, Clara Mueller, two unidentified, Caroline Butzow Mueller, and unidentified. The same basic layout, with counters on either side and shelves of goods lining the walls behind them, remained typical of small shops from the 1800s until the 1940s.

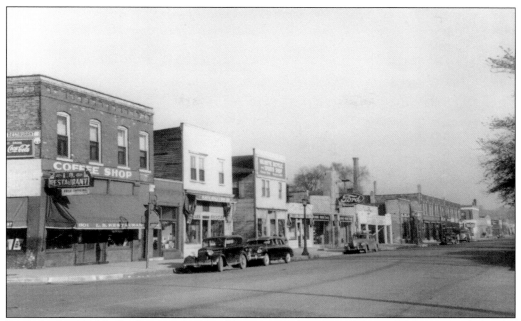

In 1948, the 600 block of Green Bay Road between Wilmette and Central Avenues includes the L.B. Restaurant (later Curt's and Crossroads) in the old Mueller grocery building, the bike shop, the Ford dealership, and, seen here in the distance, the Central Hotel building, which housed small shops on the first floor.

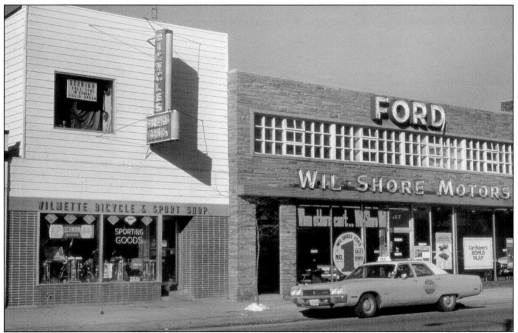

The Wilmette Bicycle and Sports Shop, shown here in 1973, was started by brothers Jim and John Versino in 1932 and has remained a fixture of village life ever since. Their sons continue to operate the business today.

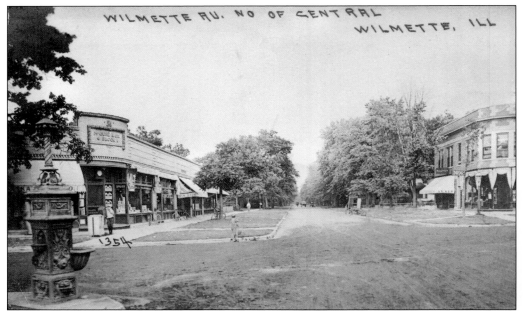

Looking north on Wilmette Avenue from Central Avenue in about 1910, this view shows some of the earliest commercial buildings downtown, at a time when sidewalks had been installed but the streets remained unpaved. In the foreground on the left is a water fountain, donated by the Woman's Club; one side was for horses, the other for people.

Taken from the same vantage point as the photograph above, this 1916 snapshot shows how much the downtown commercial space had expanded in those few years. The large white building at left housed the Village Theatre, a silent movie house opened in the summer of 1914, while, at right, the Brown Building adjoins the corner's Cox Building on the south side of Wilmette Avenue.

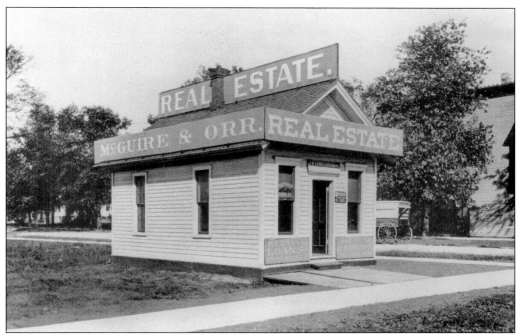

Some of the first businesses in the new village of Wilmette handled real estate, although economic conditions limited growth until the 1890s. McGuire and Orr's office, shown here in 1903, occupied John Westerfield's old surveying company headquarters at Twelfth Street and Central Avenue.

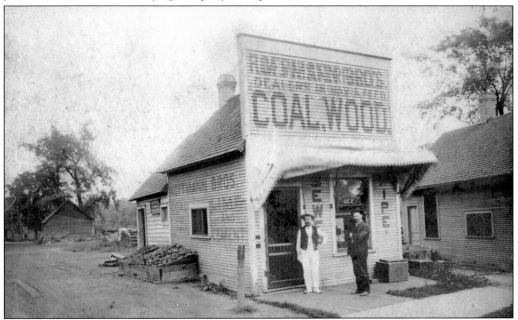

In 1898, brothers John and Philip Hoffmann bought Frank Westerfield's coal and lumber business just east of the railroad tracks at Central Avenue and Green Bay Road. This photograph, taken soon afterward, shows John Hoffmann (left) and Philip Hoffmann. The Hoffmann lumberyard closed in 1974 to make way for the new railroad station.

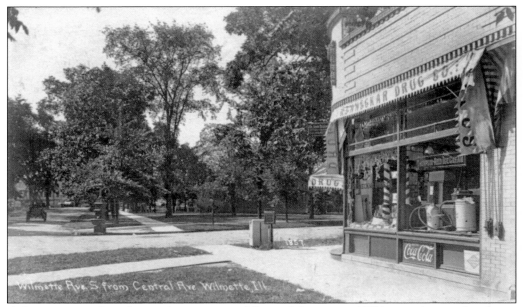

A drugstore stood on the northeast corner of Central Avenue and Wilmette Avenue for almost 100 years, until Lyman-Sargent's closed in 1998. Carl Renneckar ran the store and soda fountain here between 1908 and 1936, when he sold the business to David Lyman.

During the Great Depression, panicked depositors descended on Wilmette's two banks on Saturday, June 25, 1932. This rare snapshot shows the run on the Wilmette State Bank at Central Avenue and Twelfth Street. The bank's president calmed the crowd by pledging to stay open until all demands for withdrawals had been met. By contrast, the First National Bank at 1150 Central Avenue closed its doors that day, and never reopened.

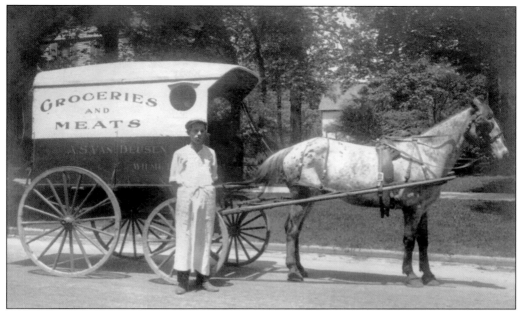

Well into the 20th century, grocery stores in Wilmette and Gross Point made regular deliveries throughout the community. Van Deusen's grocery, on Central Avenue and Twelfth Street downtown, opened in 1902 and remained in the family for 50 years. Seen here with the delivery wagon in about 1905 is Archibald Beebe Van Deusen.

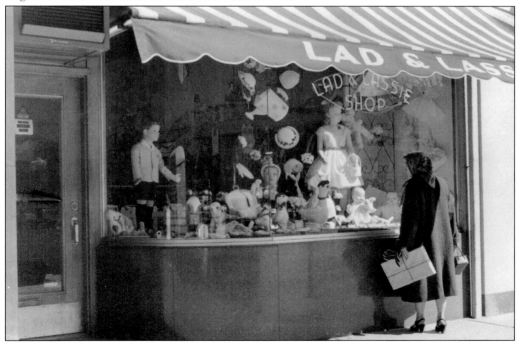

The Lad & Lassie Shop, shown here at 1114 Central Avenue in 1957, moved across the street the following year, and founder Beulah Leipsinger brought her son-on-law, Bill Evans, into the business. Bill's daughters, Mimi and Patty, own and manage the shop today.

Wilmette's Newest Business Block

A 1923 issue of *Wilmette Life* features an important addition to downtown's commercial spaces: the Rockhold Building, situated on the southwest corner of Central Avenue and Wilmette Avenue, on the site originally occupied by Alexander McDaniel's house. The building was designed by well-known architect Alfred Alschuler in the same Tudor Revival style that he employed for a similar commercial building in nearby Winnetka.

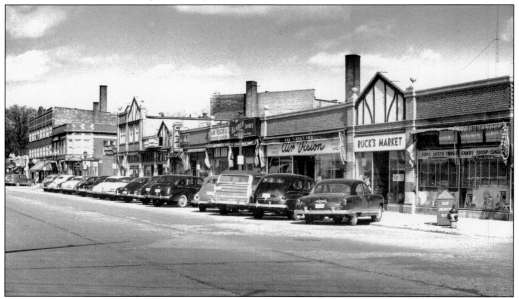

The Rockhold Building was designed to hold 14 stores and 20 offices. The portion of the structure occupying the south side of Wilmette Avenue, shown here in 1951, has housed many long-running businesses over the years.

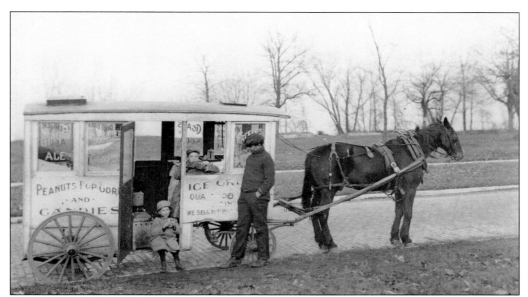

Businesses on wheels, often signaling their presence by ringing bells or playing a tune, have plied Wilmette's streets for almost as long as the village has existed. This 1905 view at Elmwood Avenue and Sheridan Road shows a horse-drawn cart offering peanuts, candy, and ice cream.

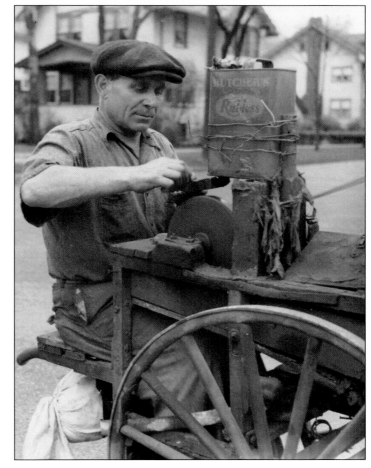

This 1940s photograph in east Wilmette shows an itinerant sharpener of knives and scissors with his portable, pedal-operated grinding stone. James Zarlenga, an Italian immigrant, wheeled his cart along the streets of Wilmette and other North Shore suburbs from the 1920s to the 1960s.

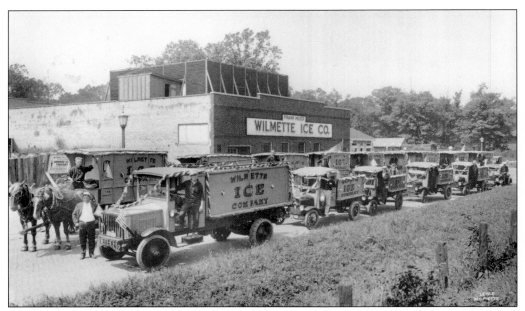

Before electric home refrigerators came into widespread use beginning in the 1930s, people relied on deliveries of ice to keep food cool in the family icebox. Children would often follow the ice truck on hot summer days to pick up slivers as a cold treat. This 1927 photograph shows the trucks of Frank Meier's Wilmette Ice Company decorated for a parade and lined up outside the refrigerated warehouse at 733 Green Bay Road.

On the southwest corner of Wilmette Avenue and Green Bay Road, shown here in about 1915, stands the Brethold Building, which for decades housed a succession of drugstores. The Lodge Hall at 1211–1217 Wilmette Avenue, long a meeting place for the local Odd Fellows lodge, was built in 1901. John Millen erected a building adjoining the Lodge Hall in 1923 to house his hardware store, formerly on Green Bay Road.

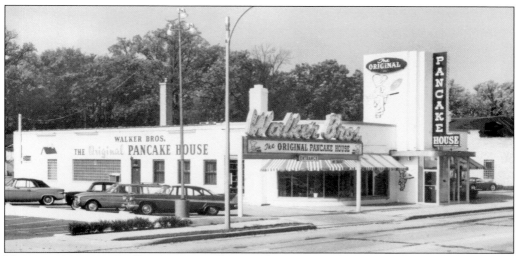

Victor and Everett Walker began Walker Brothers Original Pancake House at 153 Green Bay Road, shown here not long after it opened in 1960. The interior, originally done in Early American style, was remodeled after a fire in the late 1970s to feature Victorian décor and stained glass. Walker Brothers has long been one of the North Shore's best-known and most popular spots for breakfast.

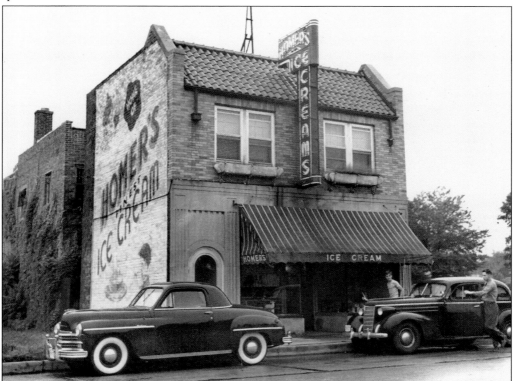

A Wilmette institution begun and still owned by the Poulos family, Homer's Ice Cream at 1237 Green Bay Road is shown here not long after its opening in 1937. Generations of area high school students have worked at Homer's as their summer jobs.

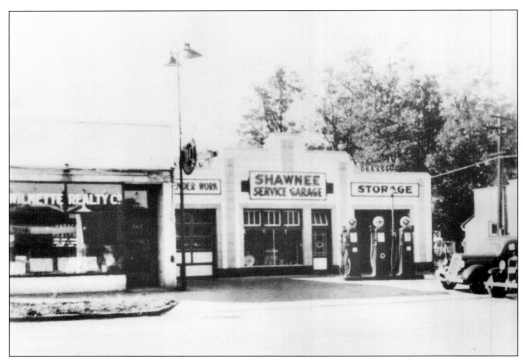

George Schaefer opened Shawnee Service in the Fourth Street and Linden Avenue business district in the 1910s, when automobiles first began to be popular. Soon acquired by Sam Marvin, later joined by Al Rodenkirk, the garage is shown here in the 1930s at its first location at 515 Fourth Street. In 1957, the business remodeled and moved to 332 Linden Avenue. The garage continues to be owned and run by the Marvin family.

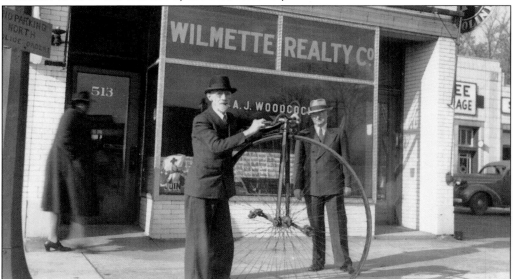

A.J. Woodcock, of Wilmette Realty Company, is shown here with his "high bicycle." His was one of a series of real estate businesses, such as Tighe Realty and Coldwell Banker, that have been located in the Fourth Street and Linden Avenue area.

A village fixture on Twelfth Street, Sweet's Tin Shop even made the molds for the first Girl Scout cookies. Frank Beitzel bought the business from John Sweet in the early 1940s. This photograph of Mary Kay Beitzel and Jane Hoth (later Beitzel) in front of the shop dates from that time. The third generation of Beitzels runs the business today.

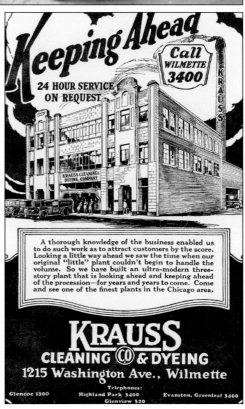

Keeping Ahead

Call WILMETTE 3400

24 HOUR SERVICE ON REQUEST

A thorough knowledge of the business enabled us to do such work as to attract customers by the score. Looking a little way ahead we saw the time when our original "little" plant couldn't begin to handle the volume. So we have built an ultra-modern three-story plant that is looking ahead and keeping ahead of the procession—for years and years to come. Come and see one of the finest plants in the Chicago area.

KRAUSS
CLEANING CO & DYEING
1215 Washington Ave., Wilmette

Telephones:
Glencoe 1300 Highland Park 3400 Evanston, Greenleaf 3400
Glenview 320

In 1928, Joseph Krauss added a third story and a distinctive brick smokestack to the building at 1215 Washington Avenue, just west of Green Bay Road, and promoted its grand opening with advertisements like this one. Shore Line Cleaners moved into the space in about 1930 and stayed for 20 years. In the 1950s, the US Army Corps of Engineers used this building for pioneering cold-weather research.

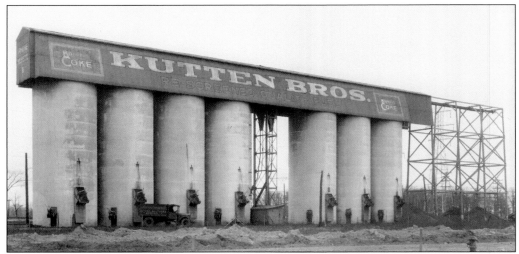

These enormous Kutten Brothers fuel silos at 3510 Wilmette Avenue, shown here in the 1930s, were familiar west Wilmette landmarks for many years until they were razed in 1957.

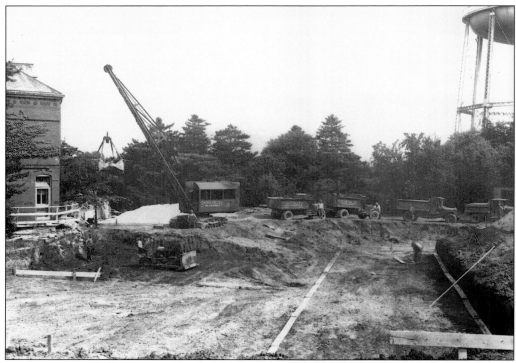

Skokie Valley Coal and Material Company, whose trucks are shown here in the 1930s excavating the foundation for the new St. Joseph Church building, was founded in 1926 by Marcus Mick and his wife, Lillian Hoffmann Mick, descendants of two pioneering families. Skokie Valley was also instrumental in the building of another area landmark, the Baha'i Temple. Now primarily a supplier of building materials, it is still run by the Mick family.

Like similar westside farm stands such as Rengel's, P. J. Schneider's popular stand at the corner of Old Glenview Road and Hibbard Road, shown here in the 1960s, was characteristic of family-owned stands that continued to operate west of Ridge Road long after the family farms of Gross Point had begun to give way to housing developments..

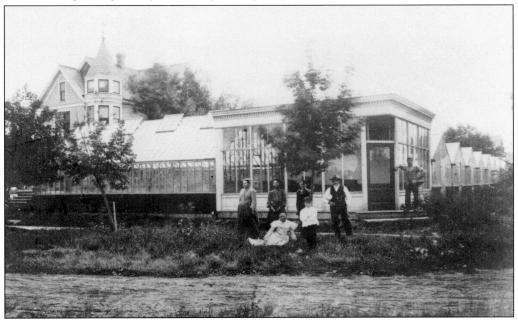

Large greenhouses were once a common sight in the village. This image of the southeast corner of Ridge Road and Washington Avenue shows how thoroughly this portion of Ridge Road was dominated by the greenhouse business of Nicholas P. Miller and his wife, Anna Felke Miller, in about 1900. The Miller home can be seen in the background to the left.

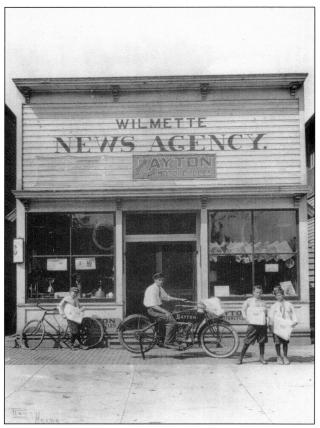

Until the 1980s, newspaper delivery was a local business in Wilmette. The Wilmette News Agency, shown here in about 1915 sharing space with a motorcycle shop at 317 Green Bay Road, functioned as a newsstand and distributorship for east Wilmette. To the west, the former Gross Point Village Hall on Ridge Road served as a distribution point for Chicago newspapers for over 40 years, beginning in the 1940s.

The center of Lloyd Hollister's North Shore newspaper empire, which would later be acquired by Pioneer Press, was this stately building at 1232 Central Avenue (across from the post office). It was built in 1928 and is pictured here in 1949. It housed the Hollister printing plant as well as the editorial offices of *Wilmette Life* and other papers. The building was demolished in 1995 to make room for condominiums.

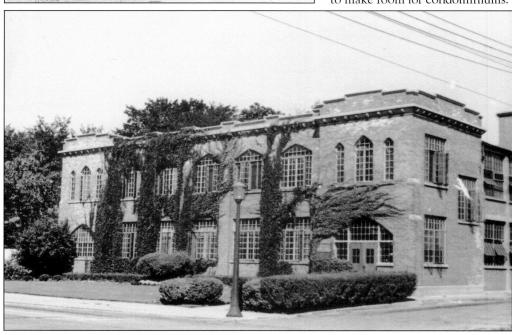

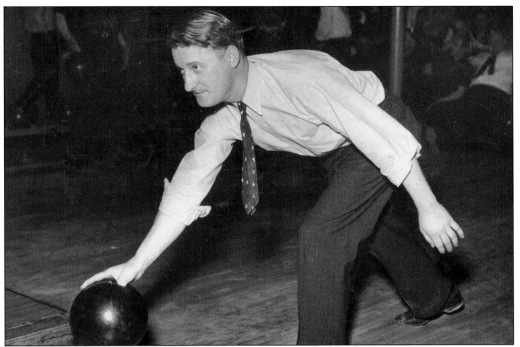

Phil Bleser, shown here in the 1930s demonstrating his bowling technique, managed Bleser's Bowling Academy at Schiller Avenue and Ridge Road for many years. The Bleser family first operated a bowling alley in Wilmette as far back as the 1890s.

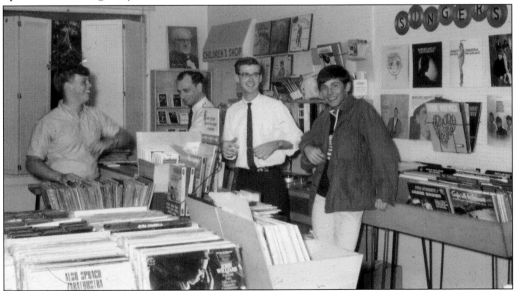

A popular hangout for teenagers and music buffs in the 1960s and early 1970s, Paul's Recorded Music is shown here in 1966 at 944 Spanish Court, shortly before it moved to 1151 Wilmette Avenue, where it remained until closing in 1974. From left to right are Robert Towner, owner Paul Siebenmann, unidentified, and Paul "Bud" Scheuble. Listening booths lined one wall of the shop.

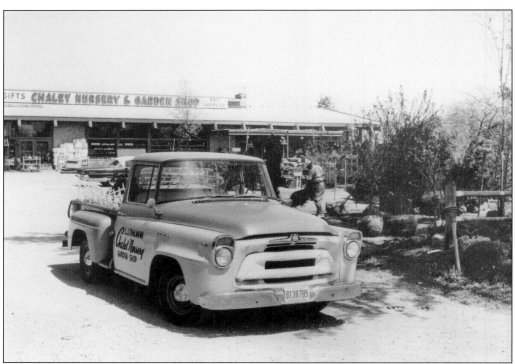

The Chalet Nursery, shown at its longtime location at Lake Avenue and Skokie Boulevard in 1958, began as a landscaping business started by Lawrence Thalmann and his uncle Jake Reinwald on Schiller Avenue in 1917. The business has remained in the Thalmann family ever since.

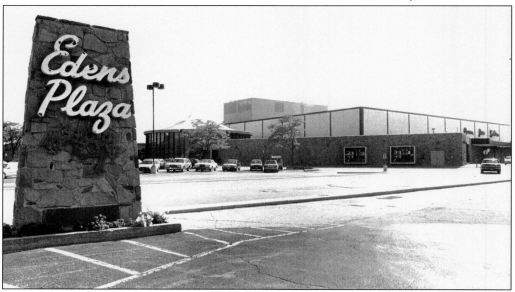

Edens Plaza at Lake Avenue and Skokie Boulevard, shown here in 1988, signaled a major change in Wilmette's business environment, bringing large-scale retail stores to the village for the first time. Over 25,000 people attended the grand opening in 1956, including 92-year-old highway pioneer Col. William G. Edens, after whom the expressway and the shopping center were named.

78

Six

NO MAN'S LAND

No Man's Land was a fun destination: part country club, part amusement park. An unincorporated triangle of land between the towns of Wilmette and Kenilworth on the lake, No Man's Land first emerged in the 1920s as a glamorous entertainment complex with a Spanish flair. New businesses included the Teatro del Lago movie palace, fashionable shops at Spanish Court (now Plaza del Lago), the Vista del Lago beach club, and the Miralago Ballroom.

The Depression put a halt to posh development. Instead, more modest businesses opened in the 1930s. These included an ice cream parlor, car dealerships, service stations, hotdog stands, and fireworks concessions. Such activities earned the area the nickname "The Coney Island of the North Shore."

Although No Man's Land was popular with many in the Chicago area, there were also those who disapproved of its existence. Movies were shown on Sundays, an activity that was frowned upon in the neighboring towns, and there were rumors of gambling and vice. The Village of Wilmette attempted to take control of No Man's Land by annexing it without the approval of those who lived there. For more than 20 years, the people of No Man's Land fought back in court. Illinois state courts denied Wilmette's first two annexation requests, ruling in favor of No Man's Land property owners, whose motto was "No Man's Land of the Free." In 1942, the Village of Wilmette finally won state approval, and the area became part of Wilmette.

After annexation, No Man's Land remained a relatively stable commercial area until controversy over a proposed motel fueled major redevelopment in the 1960s. At that time, the businesses on the lake side of Sheridan Road were torn down, and high-rise apartment buildings gradually replaced them. The new urban-style development provided multifamily housing and, except for parts of Plaza del Lago, erased the area's earlier history.

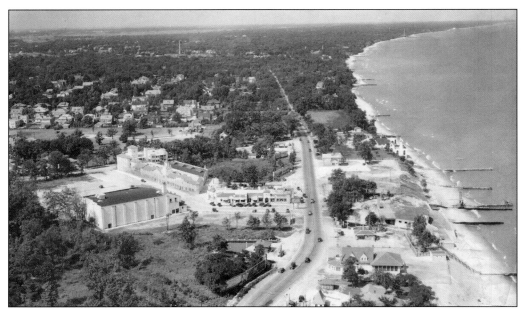

Sheridan Road gently curves through No Man's Land in this 1928 aerial photograph. The newly opened Teatro del Lago movie theater and the shops of Spanish Court are visible on the left (west) side of the road. The beach side is more casually developed with small businesses, narrow beaches, and breakwaters.

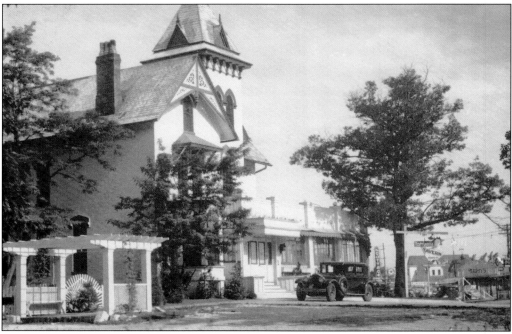

This wonderful house was built in 1874 for Henry and Mary Gage at the south end of No Man's Land. After Henry died in 1911, the house became a school and then several restaurants, including Harrison's White Chicken Tavern, whose sign can be seen on the right in this 1935 photograph. John Gage, Henry's father, purchased No Man's Land in 1857 from widow Mary Dennis.

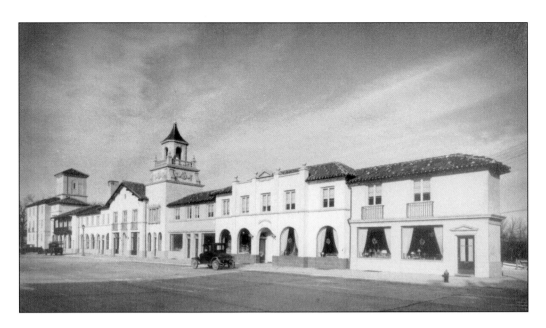

In the 1920s, a consortium of North Shore business people invested in a plan to transform the largely vacant property in No Man's Land into an elegant, Spanish-style shopping and entertainment complex and named it Spanish Court. Well-known architect Edwin Clark drew up the plans for a movie theater, shops, and apartments arranged around a parking lot, a new idea at the time. This innovative shopping center opened in 1928, the second such retail complex in the United States. These photographs were taken soon after the complex was completed. The photograph above shows shops and an apartment building on the west end. Visible in the photograph below are Spanish Court Pharmacy and Bills Realty, the firm that first marketed Wilmette's Indian Hill Estates subdivision, on the east end, and the Teatro del Lago movie theater in the background. (Both, courtesy of the Art Institute of Chicago.)

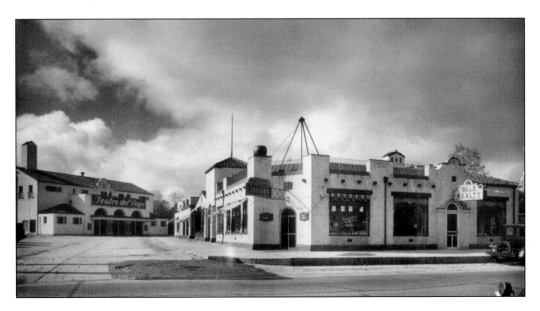

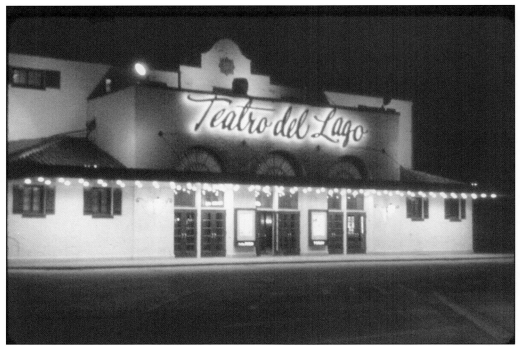

The Teatro del Lago movie palace opened in 1927, just as the first talking motion pictures were being released, but an organ was still installed for silent film accompaniment. The theater's interior was handsomely appointed with Spanish-style details and seating for 1,300 patrons. Charles Percy, Ann-Margret, and Rock Hudson worked here when they were teenagers.

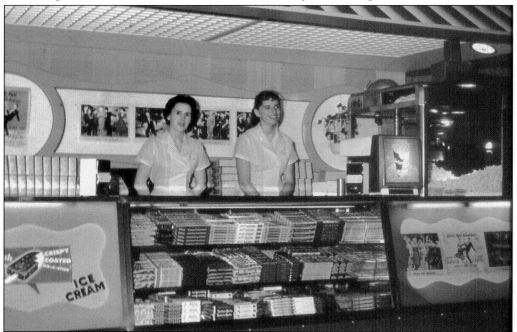

The candy counter at the Teatro del Lago was probably a later addition to the theater.

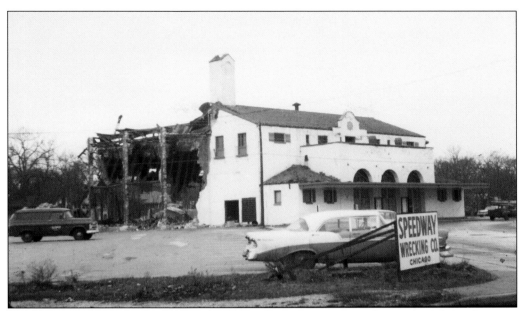

The theater came under scrutiny in the 1960s when plans were made to remodel the shopping center. Teatro owner Sam Meyers wanted to build a parking garage for moviegoers, but plans were never finalized with village government, and Meyers decided to sell the business to a developer. The theater was razed in December 1965, and a Jewel grocery store was built at approximately the same spot.

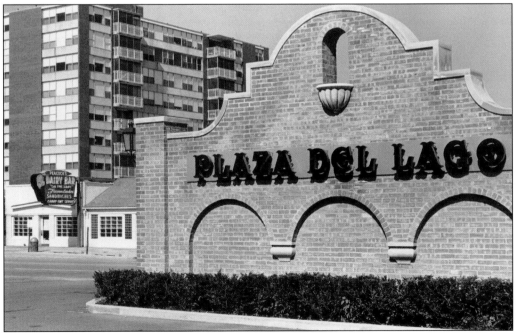

After remodeling was completed in 1967, the shopping center's name was changed from Spanish Court to Plaza del Lago. Note the contrast between the new high rise and Peacock's popular ice cream shop, which would soon move elsewhere.

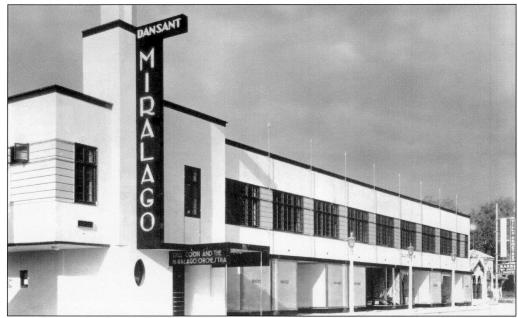

The most glamorous nightspot north of Chicago, the Miralago Ballroom made its debut in 1929. Designed by architect George Fred Keck, it was a gem of an Art Deco building and boasted a dazzling interior of silver, black, and teal, and a neon fountain (pictured below). In March 1932, this beautiful building fell victim to political feuding between unincorporated No Man's Land and the villages surrounding it. A fire broke out in the club, but jurisdictional disputes among the local fire departments so hampered efforts to fight it that by the time firefighting began in earnest, it was too late; the building burned to the ground.

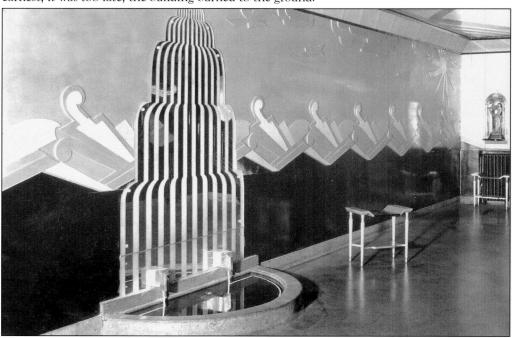

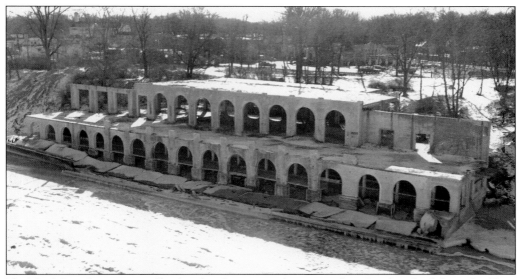

No Man's Land was originally slated to have two glamorous, Jazz Age beach clubs—the Vista del Lago and the Breakers Beach Club. Begun in 1927, the Spanish-inspired Vista del Lago was designed as a clubhouse and luxury apartment and hotel complex. Only two stories were completed of the original 10-story project, a victim of the 1929 stock market crash.

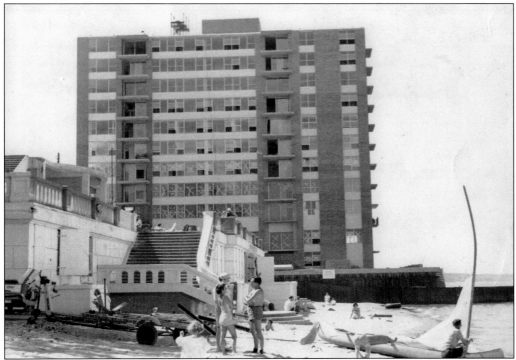

The Breakers Beach Club suffered the same fate as the Vista del Lago during the Depression. Club memberships were sold, but construction was completed only on the lower level and the staircase to a terrace overlooking the lake. The ruins of both clubs were demolished in the 1960s to make way for new apartment buildings.

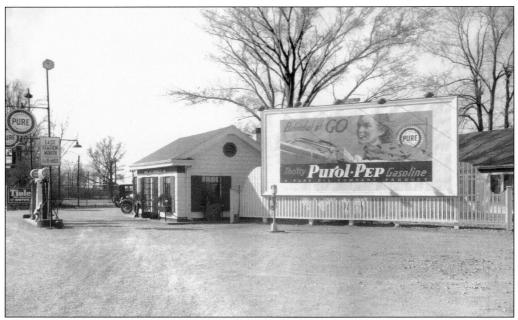

The increasing popularity of automobiles made No Man's Land a popular destination. Service stations, such as the one in this 1930s photograph, lined this strip of Sheridan Road, serving the Spanish Court clientele as well as motorists along Sheridan Road. The sign by the pumps warns customers that this is the last station north on Sheridan for 15 miles.

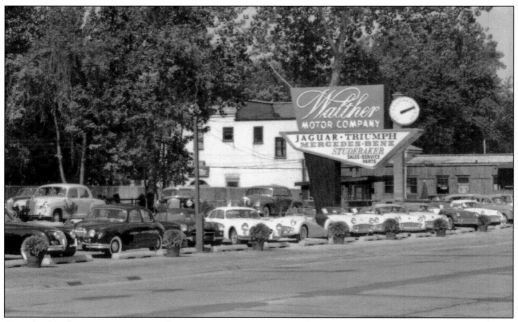

Car dealerships were once a fixture in No Man's Land. Walther Motors, seen here in 1959, specialized in used sports cars such as Triumphs and Jaguars and served as a weekend gathering spot for Chicago-area sports-car enthusiasts. Imperial Motors and Foley Motor Sales were once located in No Man's Land as well.

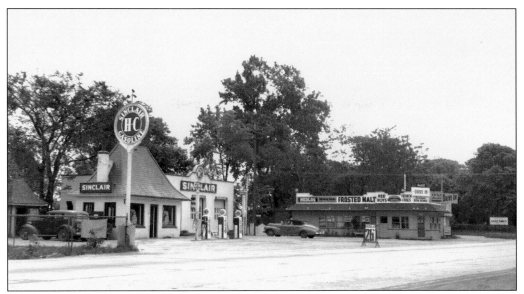

Unpretentious eateries like this drive-in, with its signs offering frosted malts and red hots, were a fun part of the freewheeling No Man's Land atmosphere in the 1940s. Notice the 26¢ per gallon gas available at the Sinclair station next door.

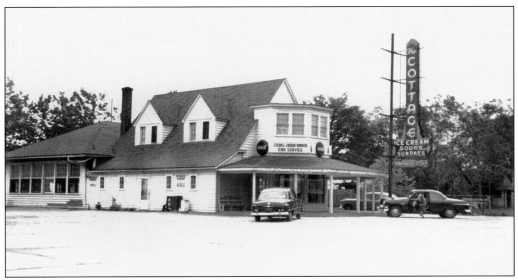

Many restaurants in the area had a beachfront air about them. Thomas Anton opened The Cottage in 1923 as a short-order eatery. In later years, the restaurant was known as "The Pink Cottage" because the exterior was painted pink. When the building was set for demolition in 1962, the Wilmette Fire Department burned it down as part of a training exercise.

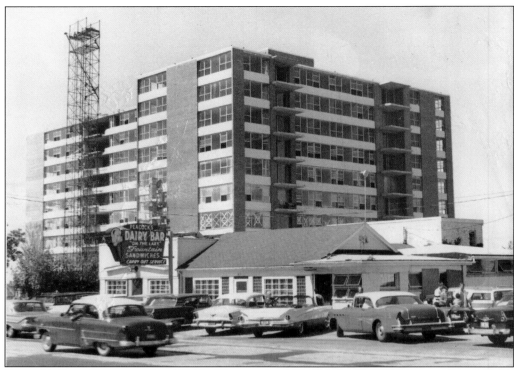

Peacock's Dairy Bar, opened in 1936 by Thomas Anton and later owned by George Bugelas, was beloved by generations of kids and adults alike for its fabulous, premium ice cream and sodas. High-rise apartment buildings constructed in the early 1960s eventually pushed it out.

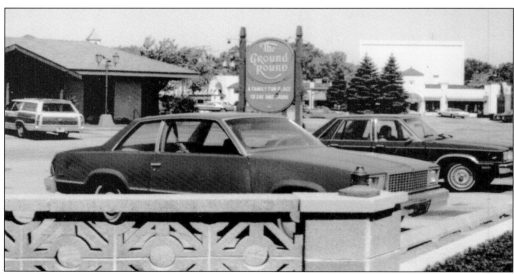

The Howard Johnson chain operated a restaurant at the southeast end of Plaza del Lago from 1967 to the early 1980s, including The Ground Round. Famous chef Charlie Trotter worked here as a teenager growing up in Wilmette. Convito Italiano restaurant occupied the space from 1982 through 2006.

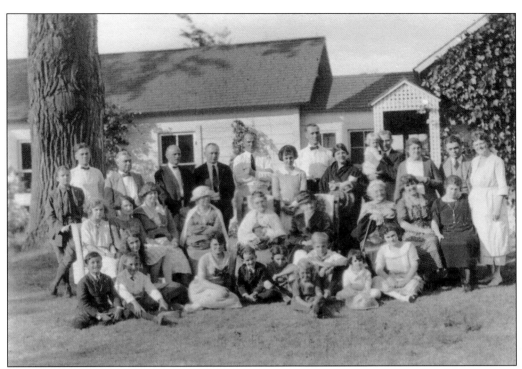

The extended Gage family gathered on July Fourth 1922 at their beachfront cottage in No Man's Land. The original owners of No Man's Land, the Gages remained a presence in the area until the 1950s.

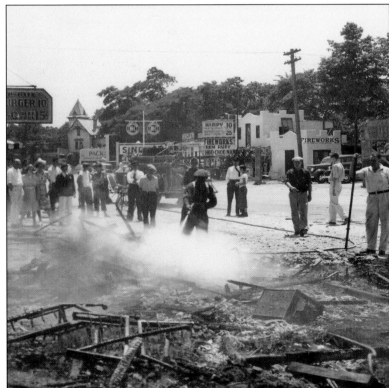

Two days before the Fourth of July 1939, one of the fireworks stands in No Man's Land exploded and caught fire, damaging the florist shop next door. Two other fireworks concessions and several hamburger stands are visible in the background.

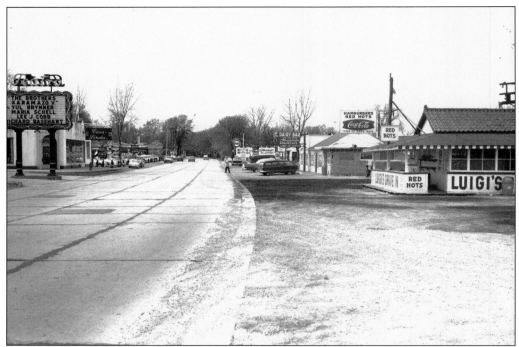

By 1958, when this photograph was taken, No Man's Land had many popular businesses on this stretch of Sheridan Road.

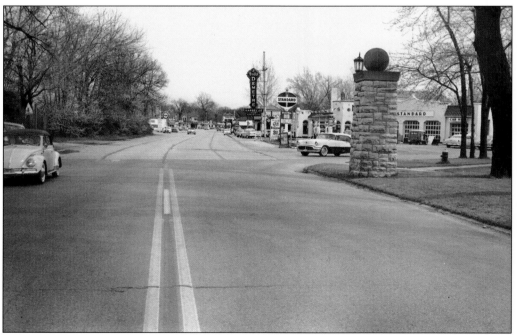

This view, looking south on Sheridan Road from the Kenilworth border with Wilmette, shows the north end of No Man's Land as it looked in the late 1950s, before the area was substantially changed.

Seven

ON THE LAKESHORE

Wilmette sits on the shore of a great wilderness, Lake Michigan. The lake has been a drawing point for many generations in this area. Early residents who grew up here in the late 1800s recalled a time when young people would gather on the beach for a swim, campfire supper, and a sing, and young boys would play hooky from school for an afternoon "forbidden swim" at the beach. Part of the beauty of the lakeshore is that it is different things to different people: a place of contemplation, a perfect summer venue for having fun with friends or family, a cooling spot on hot summer days, a fantastic spot for an outing with a favorite canine companion, or a place for brisk winter walks or runs with those rough lake breezes buffeting one about. It holds many memories for local folks.

Generations have also tried to tame the wilderness and its shoreline. Lake schooners, birchbark canoes, fishing boats, commercial ships, naval training ships, and pleasure craft have plied its waters and docked on its shores. Local residents have built piers and breakwaters to alter the currents and protect the lakefront. Modest, permanent homes began to dot the shore in the early 1800s and became more elaborate as time went by. To eliminate the deadly problems caused by the pollution of Lake Michigan, the Chicago River was reversed and a series of canals constructed. The final phase of the project was the building of the North Shore Sanitary Canal, a massive earthmoving task completed between 1907 and 1910. This transformed Wilmette's lakeshore; Wilmette Beach, Wilmette Harbor, and Gillson Park were all a result of the canal project.

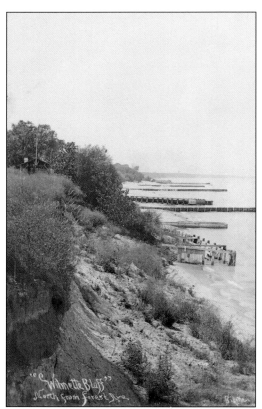

Wilmette's 19th-century shoreline was defined by 30-foot-high sandy bluffs and narrow, pristine beaches. Bluff erosion was an ongoing problem, one that the early residents attempted to solve by building piers and breakwaters. By 1904, the Village of Wilmette had organized a breakwater committee concerned with shore protection.

This 1890s photograph shows two boys running north along the beach near Gage's Pier, an early landmark at the foot of Chestnut Avenue.

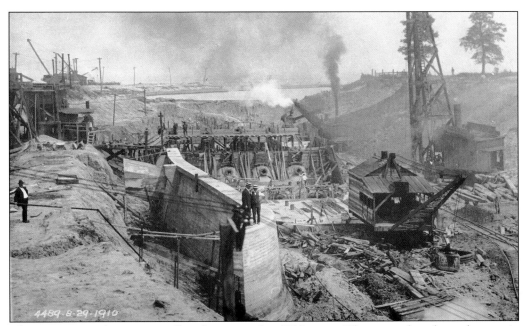

The massive canal project is well under way in this 1909 image. The steam shovels can be seen in the distance, and the railroad track used to transport the canal dirt to the landfill site is visible in the lower right corner. It was this landfill that created what is now Gillson Park.

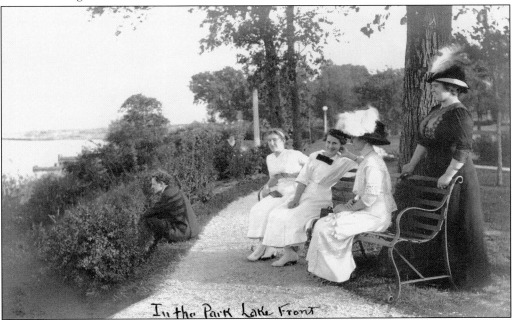

Ouilmette Park, Wilmette's first public park, was created between Lake Avenue and just north of Forest Avenue on the lakefront, starting in 1910. Serving the community during the long years required to create what is now Gillson Park, the park was largely replaced in the 1930s by the Wilmette Water Plant. This charming photograph of people enjoying Ouilmette Park was taken between 1910 and 1912.

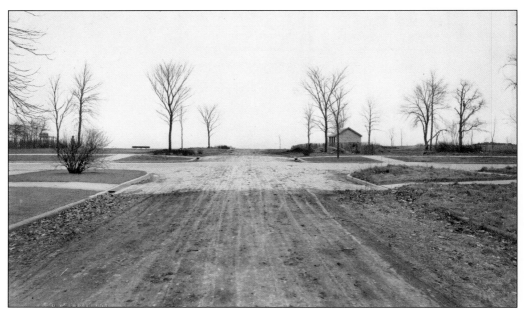

Gillson Park looks more like Gillson's Folly in this 1917 photograph. The canal dirt turned out to be an impervious blue clay, so thick and infertile that nothing would grow in it. Park District employees planted cowpeas and millet and then plowed them under in order to enrich the soil, but progress was slow. Making the park the verdant expanse that Wilmette now enjoys required decades of effort.

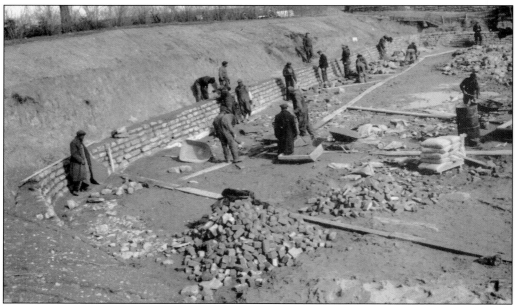

During the Great Depression, the Works Progress Administration transformed a dumpsite at Gillson Park into an outdoor performance site that was originally called Wilmette Amphitheatre. The original seats were redwood with a flagstone base, replaced in 1984 with seats of Douglas fir and Wisconsin Lannon stone. The venue was designed by Gordon Wallace and renamed after him when he retired as park superintendent, a post he held from 1938 to 1968.

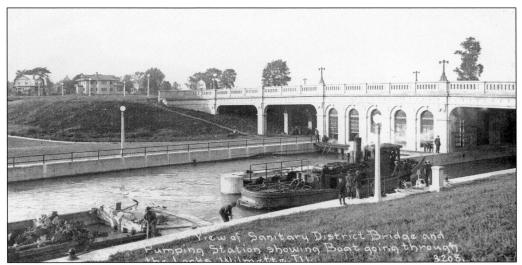

This c. 1913 photograph shows the west side of the Sheridan Road Bridge, looking northeast, with boats waiting to go through the locks and out into Wilmette Harbor and Lake Michigan. In 1961, the locks were closed to traffic when the lock gate was replaced with a vertical sluice gate.

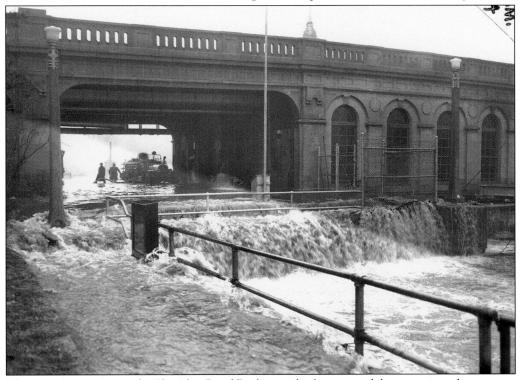

The pumping station under Sheridan Road Bridge was built to pump lake water into the sanitary channel. The locks separate the canal and the harbor, a difference of three feet. When there are heavy rains or snowmelt, the storm drains empty into the sanitary canal, and the locks are opened to allow the overflow into the lake. This 1948 photograph shows the station flooded during a particularly heavy downpour.

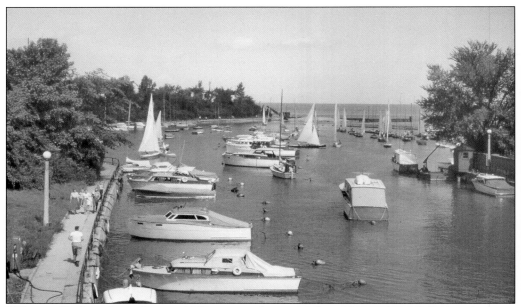

Wilmette Harbor, shown here in 1957, was an almost accidental by-product of the canal project that soon became a favorite haunt of sailors.

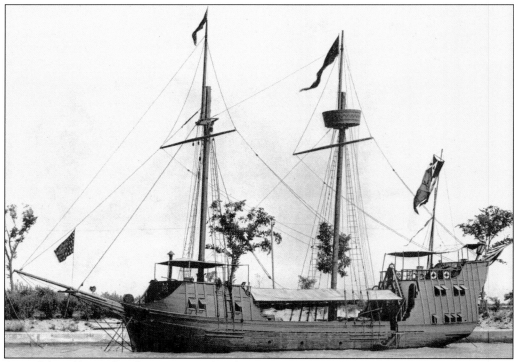

One of the oddest sights that ever graced Wilmette Harbor was *The Port of Missing Men*. Originally a lumber schooner, it was purchased in 1921 by an Evanston enthusiast and remodeled as a replica of a 15th-century caravel to serve as a merry clubhouse for the Buccaneers Club. When the club went broke in 1929, the ship was towed out into the lake, set afire, and sunk.

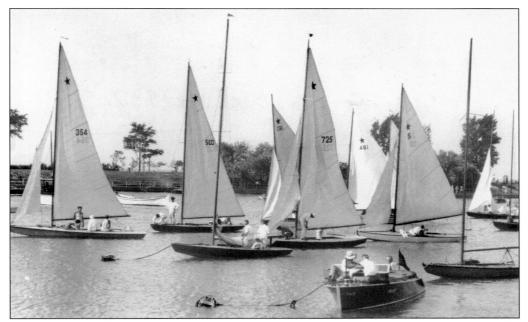

Racing has been a popular sport at the Sheridan Shore Yacht Club (SSYC) since the 1920s. The Star Fleet, shown here in about 1934, was the first to race at SSYC. The club's headquarters, completed in 1937, is located on the harbor.

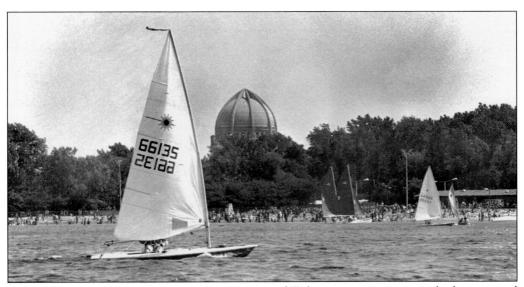

This 1980s photograph captures an iconic scene of Wilmette in summertime, looking toward the shore from the lake, with the serenely beautiful dome of the Baha'i Temple, Wilmette's best-known landmark, rising in the background.

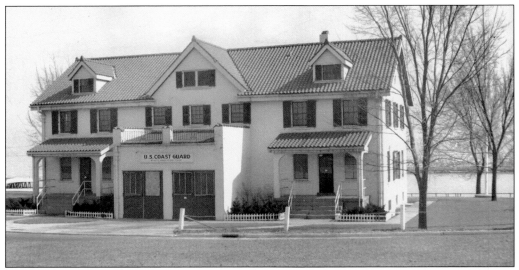

The US Coast Guard has been a presence at Wilmette Harbor since 1931, when the station (shown here in about 1948) was built. In 1982, an addition was built to the east of the original building and the white stucco removed, revealing the red brick that is visible today.

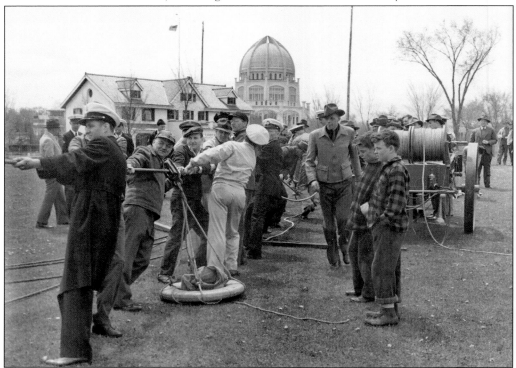

During World War II, the Wilmette Harbor Coast Guard station was given many new responsibilities and had 40 men on staff. Wilmette's Coast Guard Auxiliary, shown here in 1942 practicing a drill, was formed to help the regular Guardsmen patrol a wide area and participate in rescues. Its 64 members included many members of the Sheridan Shore Yacht Club, who used their own boats during operations.

Although the fishing shacks shown in this 1906 photograph were destroyed by a storm the following year, small-scale commercial fishing continued to be a feature of the Wilmette lakeshore for much of the 20th century. Fisherman Frank Stenberg, for example, operated Wilmette Fisheries under the Sheridan Road Bridge in the 1950s.

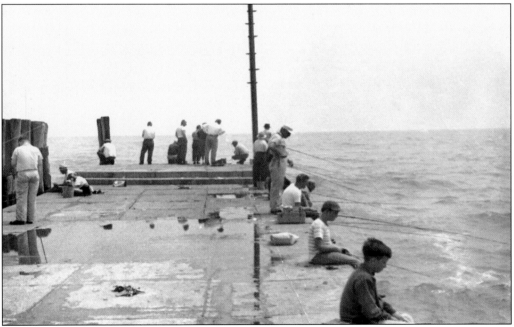

Wilmette Pier, just north of the harbor, was built in 1906 as a breakwater and remained a popular local fishing spot for many years, as shown here in 1949. Perch and smelt were particular favorites. Refurbished by the WPA in the 1930s, the pier had fallen into such dangerous disrepair by the 1980s that the remaining concrete slabs were removed and replaced by riprap boulders.

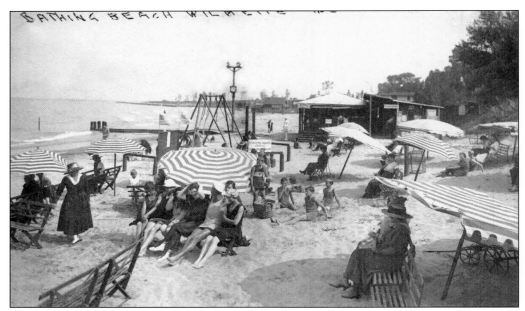

The Wilmette Beach Improvement Association began in 1914 with the goal of taking the crowded, unsupervised, garbage-strewn Wilmette shoreline and turning it into a tidy, safe, and respectable place for recreation. On the beach at the foot of Lake Avenue, the association put up a bathhouse, swings, benches, and umbrellas and hired lifeguards and a patrolman to keep watch. The improved state of affairs is captured in this 1916 photograph.

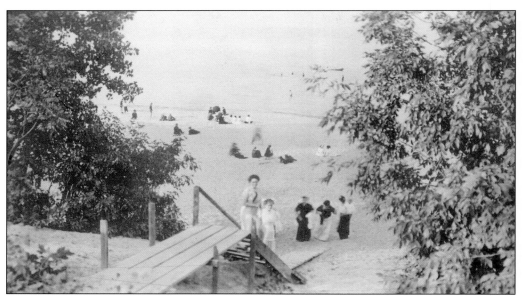

The beach at Elmwood Avenue, shown here in about 1910 with wooden steps leading down from the high bluff, was one of several small public beaches that continued in informal use long after Wilmette's official bathing beach was set up at the foot of Lake Avenue. In 1933, these beaches were officially closed to swimmers, but people still visited the Elmwood beach until a fence was put up in the 1960s.

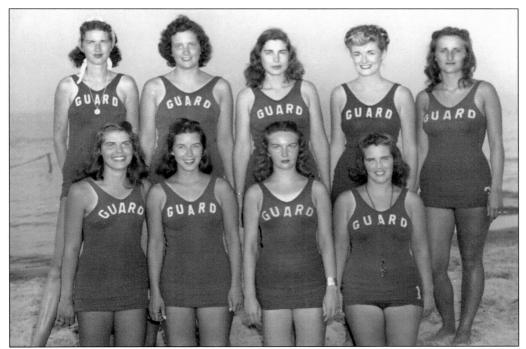

The lifeguard service at Wilmette Beach had been a male enclave, but during World War II, these young women, all of them accomplished swimmers, were hired by the Wilmette Park District to serve as lifeguards. Serving throughout the war years, they made a number of rescues.

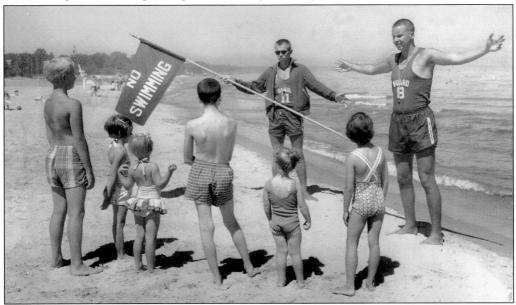

For years, despite all of the advances made in keeping pollution out of the lake, an overflowing sewer system has sometimes resulted in high bacteria counts that have closed Wilmette Beach to swimming. On one such occasion in August 1959, lifeguards Douglas Jackson and Howard Hoeper are obliged to tell disappointed youngsters that the beach has been closed.

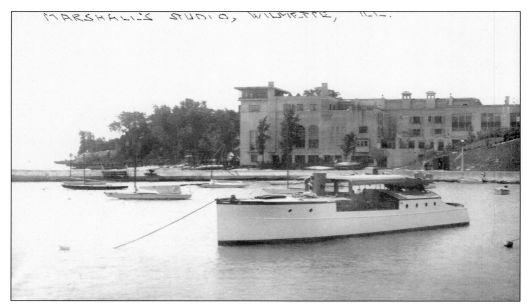

Between 1922 and 1949, Wilmette Harbor was dominated by one of the most elaborate and palatial private buildings the North Shore has ever seen: the home and studio of Chicago architect Benjamin Marshall. His magnificent 40-room, pink stucco mansion on the south side of the harbor—this 1920s view gives some sense of the scale—also housed Marshall's architectural offices and was stuffed with rare art and furnishings.

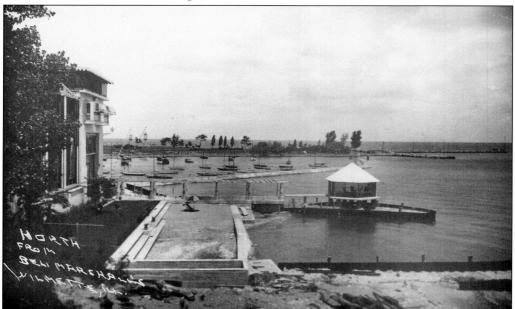

This photograph looks north from Benjamin Marshall's house, beach, and cabana toward Gillson Park. By agreement with Marshall, the yacht club used part of the ground floor of his villa as its headquarters. Hard hit by the Depression, Marshall sold the house to Nathan Goldblatt in the 1930s. In the 1940s, the Goldblatt family offered the house to the village board. The board declined the offer, and the mansion was demolished between 1949 and 1950.

Eight

VILLAGE OF HOMES

Every Wilmette neighborhood is like a time machine, whisking the passerby from one era to another in the space of a few blocks. Here is a 1950s ranch house; over there, a 1870s Italianate mansion; across the street, a Prairie-style house from the early 20th century; and down the block, a 1920s bungalow. Each house reflects the distinctive tastes and ways of life of the era in which it was built. Wilmette is a village of homes, and an essential part of its history is linked to residential development.

Three major periods of growth—the 1890s, between the end of World War I and the Depression, and post-World War II—brought dramatic physical, social, and demographic changes to the village. The 1890s saw the village transition from a rural community to an emerging suburb with strong connections to Chicago. With the support of local government, the railroad built a lovely new train station, water and sewer systems were installed, and the streets were paved with brick. These changes attracted city businessmen and their families to the village. The late 1910s and the 1920s saw increasing prosperity, and the building of many new homes. Wilmette's population tripled, from 4,943 in 1910 to 15,233 in 1930. After World War II, housing shortages caused by returning veterans and their new families fuelled a boom in home construction, while a massive interstate-highway building program linked the city and suburbs. Expansion possibilities in Wilmette were mostly west of Ridge Road, which historically had been farmland. Large contracting firms built whole subdivisions of similar-looking houses, a rare phenomenon in Wilmette up to that time. This era transformed the face of Wilmette and brought the population to over 32,000, a historic peak.

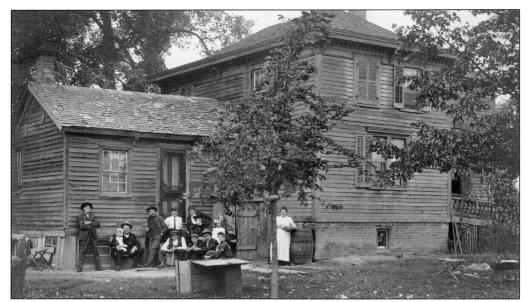

Wilmette's earliest residents chose to settle along the lakeshore and the Green Bay Trail. Most built log and wood shingle houses. This farmhouse, located near Michigan and Elmwood Avenues, belonged to the Dusham family, who moved to Wilmette in 1837 from eastern Canada. The property also included a shed built from lumber that washed up from the 1860 wreck of the *Lady Elgin* lake schooner.

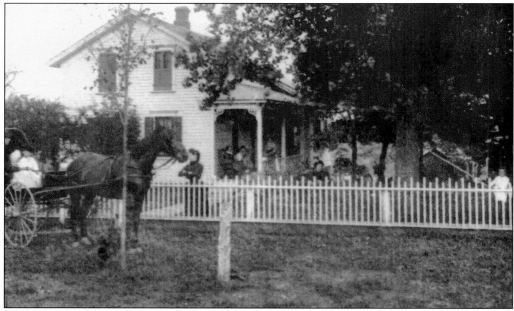

Bartholomew and Veronica Hoffmann and their children came to Wilmette from Germany in 1844. Upon arrival, they purchased farmland and erected a log cabin. After three years, the family built this Italianate-style home on Ridge Road, and the cabin became a schoolhouse, seen on the right through the trees. Five generations later, descendants of that pioneering family still live there.

John Gage purchased 118 acres in east Wilmette in 1857, and three of his children later built homes there. In 1873, son Asahel and his wife, Helen, built this magnificent Italianate house with an ornate tower. Early Wilmette homes were often set on a large piece of property, as illustrated in this 1880s view, but later, these large parcels were often subdivided. Pictured below are members of the Gage family and their Kellogg relatives relaxing on the steps of this same Elmwood Avenue house in about 1895.

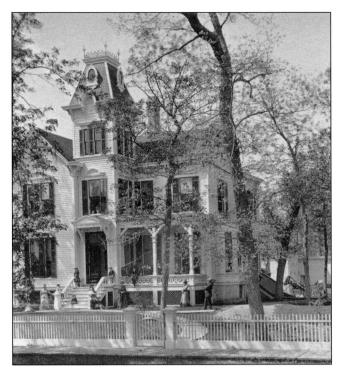

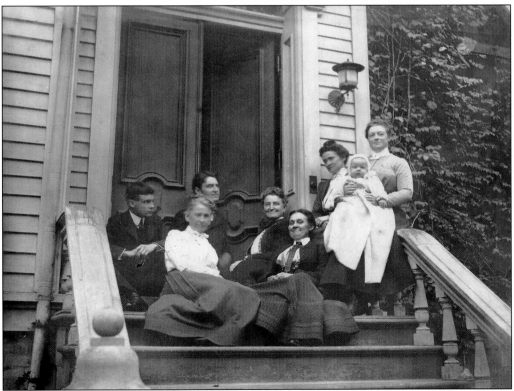

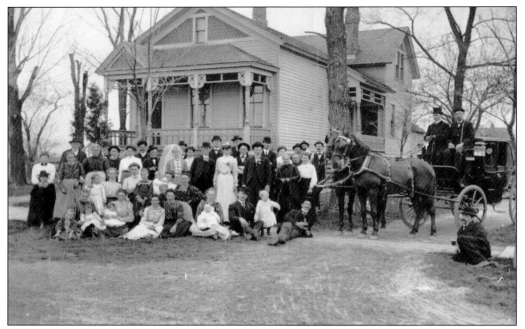

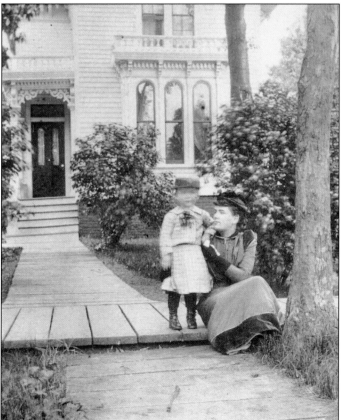

Having fled the Great Chicago Fire in 1871 with their belongings packed in a wheelbarrow, Joseph and Caroline Thalmann resettled in his hometown. They built this modest Victorian house on Lake Avenue. In this 1903 photograph, the family gathers at the house to celebrate the wedding of John Thalmann and Susanna Weinz.

On the other side of town, the Doig family built an imposing Italianate-style home on Greenleaf Avenue, then known as Depot Place. Daughter Jane Doig and an unidentified child are posing on one of the plank sidewalks that were ubiquitous in 1800s Wilmette.

This attractive 1880 newspaper advertisement by E.T. Paul & Company promotes Wilmette's sylvan lakeshore location. Agents like Edgar T. Paul paid for prospective customers to ride the train to Wilmette and tour the suburb. Paul was Wilmette's village president from 1892 to 1893.

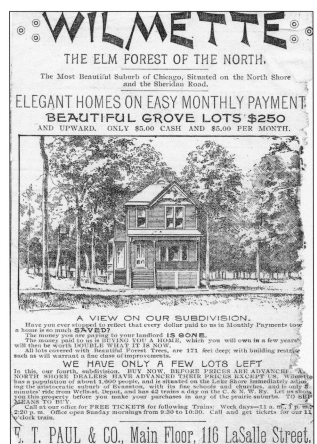

WILMETTE

THE ELM FOREST OF THE NORTH.

The Most Beautiful Suburb of Chicago, Situated on the North Shore and the Sheridan Road.

ELEGANT HOMES ON EASY MONTHLY PAYMENT

BEAUTIFUL GROVE LOTS $250

AND UPWARD. ONLY $5.00 CASH AND $5.00 PER MONTH.

A VIEW ON OUR SUBDIVISION.

Have you ever stopped to reflect that every dollar paid to us in Monthly Payments tow a home is so much **SAVED?**

The money you are paying to your landlord **IS GONE.**

The money paid to us is BUYING YOU A HOME, which you will own in a few years' will then be worth DOUBLE WHAT IT IS NOW.

All lots covered with Beautiful Forest Trees, are 171 feet deep; with building restric such as will warrant a fine class of improvements.

WE HAVE ONLY A FEW LOTS LEFT

In this, our fourth, subdivision. BUY NOW, BEFORE PRICES ARE ADVANCED. A NORTH SHORE DEALERS HAVE ADVANCED THEIR PRICES EXCEPT US. Wilmette has a population of about 1,600 people, and is situated on the Lake Shore immediately adjoing the aristocratic suburb of Evanston, with its fine schools and churches, and is only 8 minutes' ride from Wells-st. Depot, and has 42 trains a day on the C. & N. W. Ry. Let us show you this property before you make your purchases in any of the prairie suburbs. TO SEE MEANS TO BUY.

Call at our office for FREE TICKETS for following Trains: Week days—11 a. m., 1 p. m., 2:20 p. m. Office open Sunday mornings from 9:30 to 10:30. Call and get tickets for our 11 o'clock train.

E. T. PAUL & CO., Main Floor, 116 LaSalle Street,

In the 1880s and 1890s, the Queen Anne style was popular in Wilmette. Many, like this one on Central Avenue, featured a large porch across the front, a tower to one side, bay windows, and a generally asymmetrical appearance.

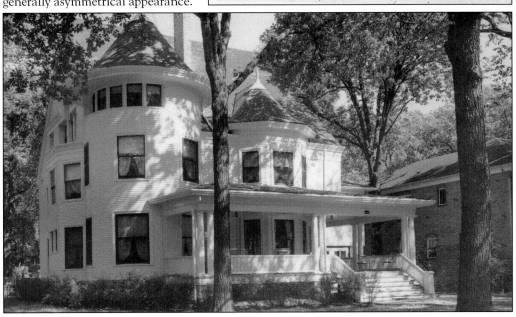

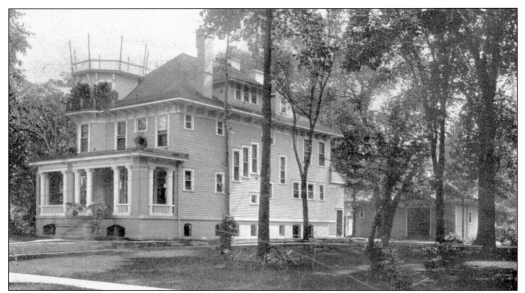

During the late 1800s and early 1900s, many Wilmette families were making a living in Chicago, a change from earlier days when the majority of residents were locally employed. The increased incomes meant more elaborate, architect-designed houses, like this one on Forest Avenue, designed by architect Dwight H. Perkins in 1899 for the Thomas Knox family. Knox was an insurance executive in Chicago. Note the stables and the striking belvedere with a wrought-iron railing, probably built to gain a view of the lake.

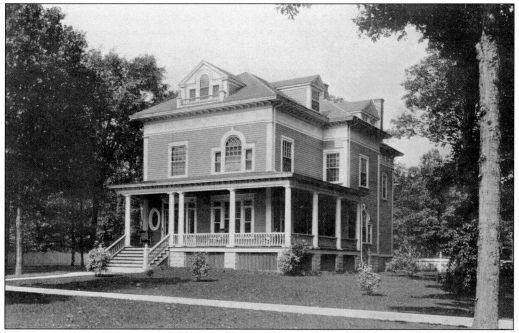

During the building boom in the late 1890s, many larger houses were added on the east side of the village, such as this one built about 1898 for Rudolph Williams. Patent attorney Louis Gillson, after whom Gillson Park is named, purchased it in 1903 and lived there for many years.

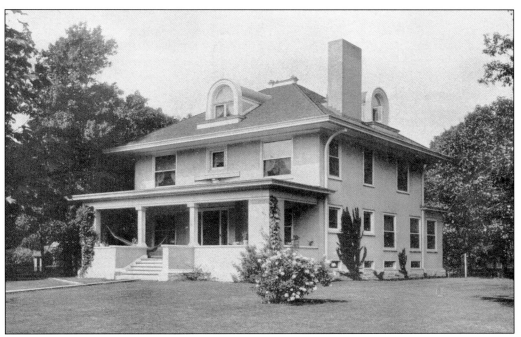

Stucco became a popular building material around 1900, and Wilmette boasts many stucco Foursquare houses. This residence on Forest Avenue is a particularly lovely and early example, designed in 1898 by architect George W. Maher of neighboring Kenilworth.

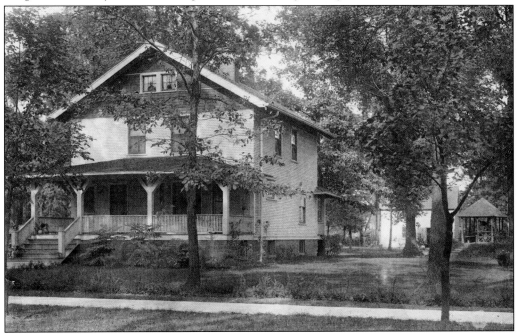

The Craftsman style was fashionable in the early 1900s, and there are many examples in Wilmette. This Park Avenue home was built by James Crabb for the Mueller family. The Crabb family construction business erected many Wilmette homes between 1893 and 1985.

John Nourse, a Civil War veteran, made his fortune in the lumber business in Chicago. In 1909, he built a Wilmette house with many Prairie-style features. However, Nourse grew up in the Victorian era, and his home decor reflects that 19th-century sensibility.

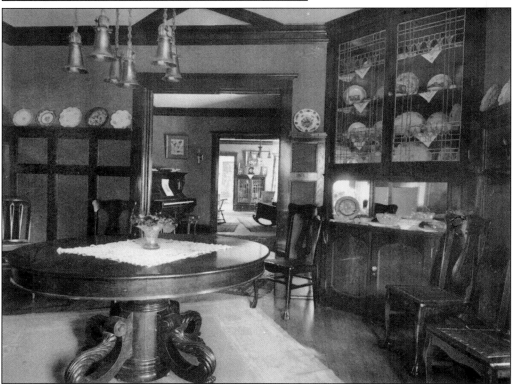

This lovely Elmwood Avenue home was built about the same time as the Nourse house on Greenwood several blocks away. By 1900, house interiors had moved away from Victorian ornamentation and began adopting built-in furniture and cleaner lines. The original owners, the Southworths, furnished it with some Arts and Crafts–style items fashionable at the time and in keeping with the architecture of the house.

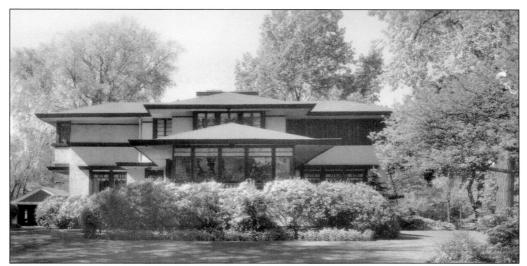

Wilmette has fine examples of homes in the Prairie School style. John Van Bergen designed this residence on Ashland in about 1913. Van Bergen had been employed by several Prairie School architects, including William Drummond and Frank Lloyd Wright, before opening his own practice. This was one of his first large projects.

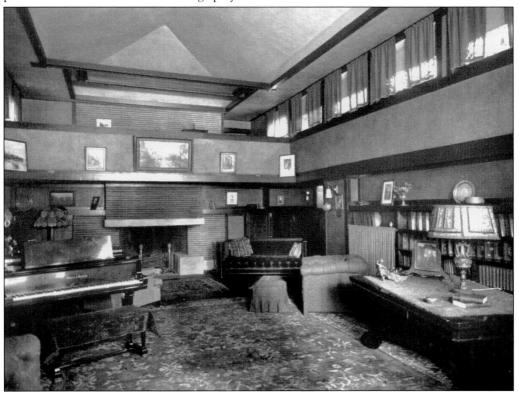

Frank Lloyd Wright designed two homes in Wilmette. The two-story living room of the 1909 Frank J. Baker house on Lake Avenue features many of Wright's hallmarks, such as the balcony above the fireplace overlooking the room, the bands of art glass windows, and the central fireplace.

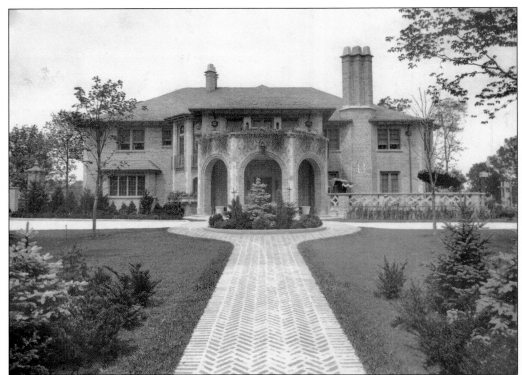

The 1920s were boom years in America, and this prosperity is reflected in some of the fine homes constructed in Wilmette at the time. Two sisters had fabulous, Mediterranean-style houses, practically identical in appearance, built next door to one another on Chestnut Avenue. The two homes also shared a large, elaborate garden and pool.

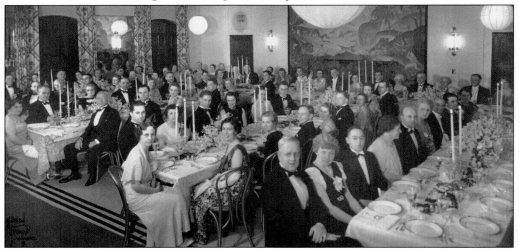

Among the luxury homes designed during the Roaring Twenties was Lochmoor, a lakefront house on Michigan Avenue completed in 1931 for the Dubbs family, who had made a fortune in the oil business. The recreation room was large enough to hold an elaborate dinner in honor of the marriage of the Dubbses' son in 1935. The house was full of special features, including a map room to plan trips abroad, a beach room with showers, and an elevator.

The development of Indian Hill Estates began in 1926. The subdivision included individually designed homes on spacious, well-manicured lots, deep setbacks, and gently winding roads. Mary Drucker, wife of the developer, is credited with naming the streets in keeping with the subdivision's Native American theme.

The early home designs in Indian Hill Estates were given descriptive names as a way to market the area and give it a tone of European elegance and class. This Norman Revival–style house, built in 1929, was known as the Chateau.

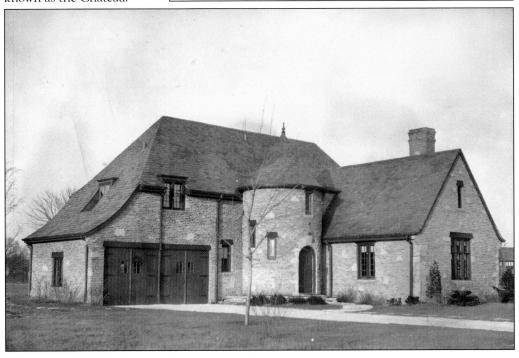

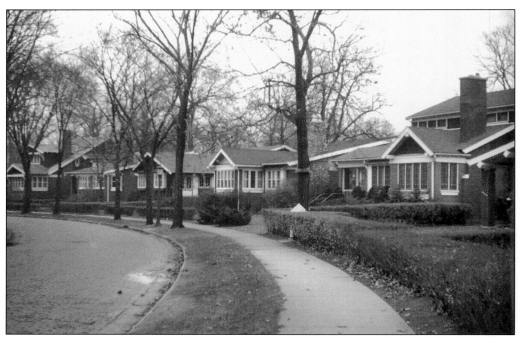

Linden Crest Apartments

Linden Avenue and Fifth Street
WILMETTE

One of the Entrances of the Linden Crest.

WHY NOT YOU?

Many representative North Shore families are making the Linden Crest Apartments their home. You are invited to inspect the few choice apartments still remaining unoccupied. You will be attracted by the apartments themselves, the delightful neighborhood, and the moderate rents.

For Information call
R. T. Davis, owner, Main 3012 or Wilmette 589
or see Janitor at Building

Linden Ave. and Fifth St., Wilmette

This block of bungalows on Oak Circle is characteristic of the 1920s. Arthur W. Dickinson, a developer in Chicago's Bungalow Belt, was responsible for building these 15 houses, all of which include such Arts and Crafts features as decorative art glass windows, low-pitched eaves, and exposed rafter tails. This architecturally unified neighborhood is a national historic district.

In early 1924, a permit was issued for the construction of the Linden Crest Apartments at Fifth Street and Linden Avenue, the first apartment building in town. This project sparked a political firestorm and a "No Flats" campaign in the local election that year. As a result of this controversy, few apartment buildings were built in the village until the 1960s.

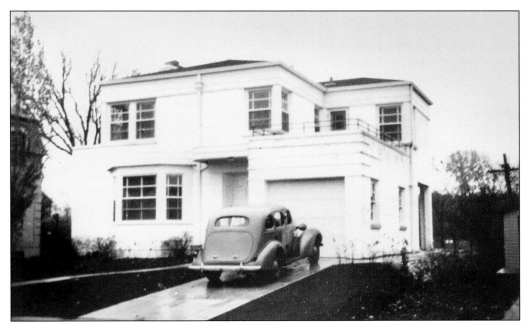

The Great Depression of the 1930s halted almost all construction, and many in the building trades lost their jobs. Federal assistance put many architects and tradesmen back to work by the middle of the decade, and home construction slowly started again. More modest homes were built than in the 1920s, however. Much of Wilmette's Kenilworth Gardens subdivision was built after 1935, including this recently completed house on Thornwood Avenue.

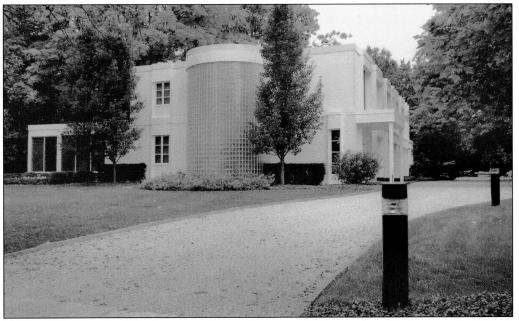

Architect George Fred Keck designed many homes in Wilmette, but this International Style residence is unique. Industrial materials such as a steel frame, concrete floors, and a curved, glass-brick stairwell wall were chosen to create this elegant 1937 home.

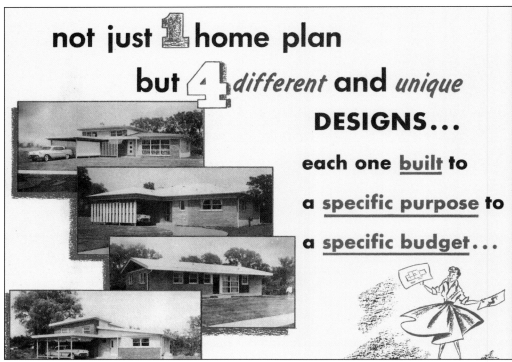

not just **1** home plan
but **4** *different* and *unique*
DESIGNS...

each one <u>built</u> to
a <u>specific purpose</u> to
a <u>specific budget</u>...

In the 1950s, developers offered buyers a choice of housing models at different price points and capitalized on an association with sunny and glamorous California. The four models featured in this brochure from Chicago-based Hollywood Builders, are (top to bottom) the Skylark, the Devon, the Trade Winds, and the El Dorado. Many such homes were built in west Wilmette on what had been farmland.

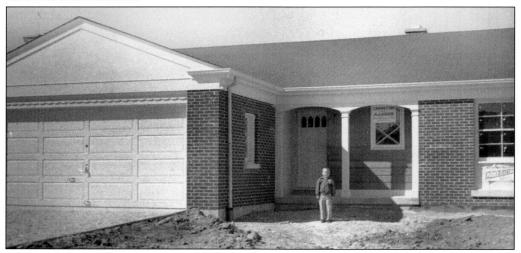

The ranch house, like this one on Highcrest Drive, was an interpretation of the 19th century California ranch house. In post–World War II home designs, floor plans were open, always contained a family room, and often opened onto an enclosed patio or courtyard, emphasizing a casual lifestyle. The split-level also became popular, as more living space could be accommodated on a small lot.

Nine

COMMUNITY LIFE

The activities that bring a community together for a common purpose help define its character.

Education has long been an important focus in Wilmette, and schools were founded before the town was even established. Churches and synagogues have also been significant social centers. The earliest church was founded in 1845, followed by various Protestant denominations in the 1870s, the Baha'i in 1908, and Jewish congregations in the 1950s. Today, more than 20 churches and temples are active in the village.

Local clubs have brought residents together since at least the 1870s. Early groups included literary clubs such as the Wilmette Atheneum, social groups such as the Sunday Evening Club, and fraternal societies such as the Odd Fellows and the Masons. Service organizations have focused on a wide variety of issues and topics. Among the longest continuously operating organizations are the Woman's Club of Wilmette (1891), the Wilmette Rotary (1924), the League of Women Voters of Wilmette (1924), and the Wilmette Garden Club (1922), just to name a few. Men and women have also been active in local politics, volunteering on local governmental commissions or running for elected office. Sports and recreational opportunities have been plentiful, from youth soccer leagues to sailing clubs.

Misfortunes and celebrations have also brought people together. In 1987, the people of Wilmette rallied around a child with AIDS, and the school district created a model approach to keeping the child in school. People have also helped one another out in times of natural disasters and tragedies, like the 1920 Palm Sunday tornado. The community has come together to celebrate such milestones as the Armistice at the end of World War I in 1918 and the Village Centennial in 1972, as well as the annual Memorial Day observance.

From the days when folks gathered around the stove at the general store to gossip, informal events—such as block parties, book clubs, and neighborhood coffee groups—while not often captured on film, have certainly been important parts of the fabric of life in Wilmette as well.

Sociability was important in early village life, and many small clubs and associations were formed. Pictured here in 1900 are members of the Social 30 Club, gathered on the front porch of Walter and Emma Butz's home at Eighth Street and Lake Avenue. Fifteen couples belonged to the group, and they met monthly at a different member's house for entertainment.

The idea for the Ouilmette Country Club (now Michigan Shores Club) came out of a casual conversation among a group of families picnicking at Gage's Pier in 1897. The first club members built a wooden shelter in the woods at Ninth Street and Ashland Avenue, later adding tennis courts and a nine-hole golf course. They also had fun putting on theatricals and raising money by organizing events like the county fair, shown here.

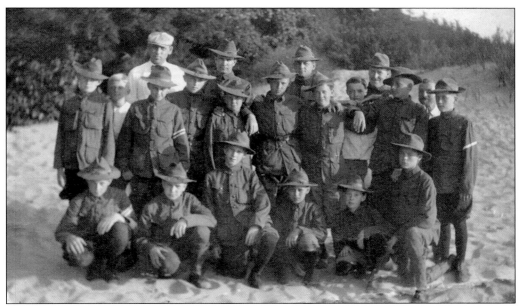

The first Boy Scout troop west of the Alleghenies was founded in Wilmette in 1910, the same year scouting came to the United States from England. This real-photo postcard shows that first group of boys at camp in Saugatuck, Michigan, in July 1911. The troop's early leaders, from left to right in the back row, are J. Robb Harper, C.H. Mowry, A.L. Rice, A.J. Coburn, and Dr. F.A. Karst.

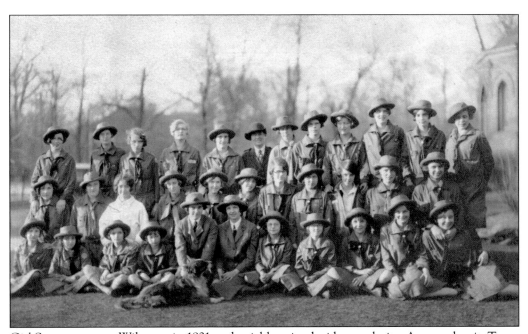

Girl Scouts came to Wilmette in 1921 and quickly gained wide popularity. A second unit, Troop No. 2 (shown here) was organized by 1927, the year this photograph was taken. In the 1930s, Wilmette Girl Scouts pioneered the sale of Girl Scout cookies that were made at a local bakery and molded with the trefoil emblem.

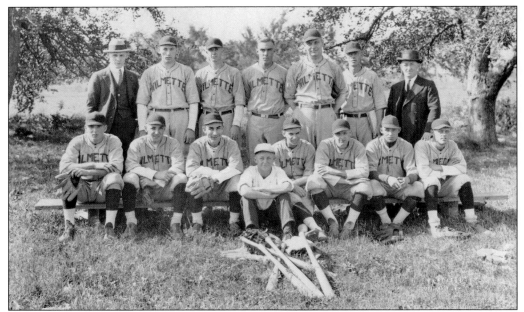

Baseball has been a popular pastime in Wilmette and Gross Point since at least the 1870s and long included both amateur and semiprofessional teams. Teams and their sponsors would vie for the best players. This classic picture is of the Wilmette baseball team in about 1921.

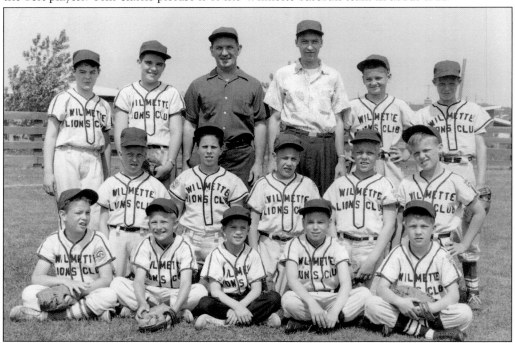

Boys' youth baseball was founded in 1951 by the Wilmette Baseball Association under the guidance of resident John Bordes. By 1962, when this photograph was taken, the association boasted 52 teams with more than 900 young players. One of those players, Bill Murray (third row, second from right), would grow up to become a well-known actor.

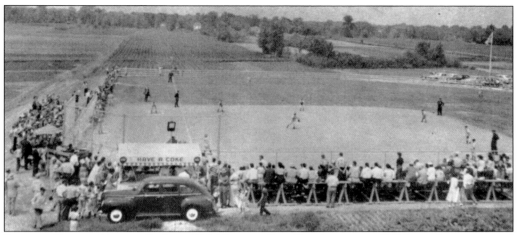

For over 50 years, Roemer Park on Old Glenview Road has been one of Wilmette's most special places. A Little League park boasting many of the features of major league stadiums, the park has always been solely dedicated to baseball. Community members worked together, donating money and labor to transform former Roemer family farmland into a baseball field. This 1953 view shows the field in its first season.

A unique undertaking on the local sports scene was the construction of the Wilmette Curling Center in 1968. Curling enthusiast Darwin Curtis of Winnetka (on right in tam) donated $400,000, and a little money was added from a Village of Wilmette fund to pay for its construction. The center remained open until mid-1978, by which time costs had outstripped revenues. The building was converted to senior housing in 1982.

Service to the community is an integral part of village life for many residents. The Wilmette Health Center, begun in 1918, offered free medical and dental care to residents who could not afford it. During the Depression, demand for services increased, and in an effort to keep those services free, center board members, such as the women shown here in 1936 with Fire Chief Walter Zibble, raised funds with Tag Days.

More than 400 men from Wilmette and Gross Point served in World War I, and there was considerable support on the home front for those servicemen. The women of the Wilmette branch of the American Red Cross Auxiliary gathered in a downtown building to knit socks and create packages of other essential items to send to the soldiers. (Courtesy of the Wilmette Public Library.)

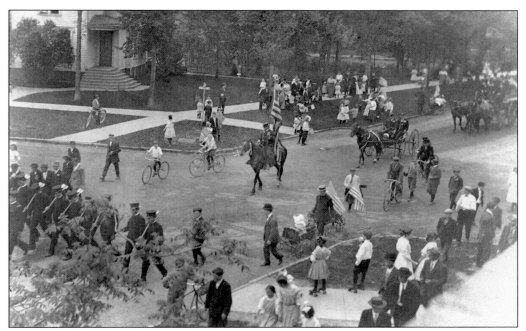

Memorial Day is an important community event. Wilmette has hosted a Memorial Day parade for over 100 years. This particular photograph was taken in 1905, and shows the parade moving east on Wilmette Avenue at Central Avenue. The house in the background belonged to the Alexander McDaniel family.

This 1941 image captures a moment of the Memorial Day Parade on Wilmette Avenue at Green Bay Road. The parade sometimes ended at village hall for speeches and sometimes continued on to Wallace Bowl at the lakefront. Businesses seen in the background include Wilmette Pharmacy and Millen Hardware.

Wilmette's 19th-century Fourth of July celebrations included reading of the Declaration of Independence and baseball games. By the 1920s, festivities included a full afternoon of races on the Village Green (now Howard Park). There were, for instance, the 25-yard wheelbarrow race for young girls and the three-legged race for husbands and wives. People also hung flags on their houses and cars, like the Jones family, seen here in 1917.

The Fourth of July has become a memorable, community-wide event. Huge crowds attend the festivities, which include races (seen here in 1987), pie-eating contests, and other activities at Gillson Park, followed by a fireworks display over the lake at night. This major event was created in 1969 by a dedicated group of volunteers led by Edmund Barys, and the Wilmette Park District took it over nine years later. Today, the celebration is held on the third of July.

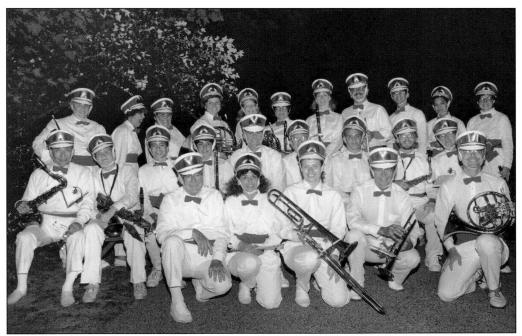

Many residents participate in theatrical and musical groups, both informal neighborhood groups and more formal associations such as the Wilmette Community Band, shown here in 1989. They are dressed to perform *The Music Man* at the Starlight Theater, Wallace Bowl.

Free summertime concerts, plays, and other events have been offered at Wallace Bowl since 1937, when it first opened. This delightful outdoor amphitheater near the lake is a much-loved community venue.

The 100th anniversary of the founding of Wilmette was celebrated in September 1972 in grand style. Festivities including a multitiered cake, a downtown parade, a street dance, and a fair with displays from over 150 artists and antique dealers, games, food, and entertainment.

The centennial celebration drew thousands of people to its events in a show of real community spirit.

ABOUT THE MUSEUM

The Wilmette Historical Museum was established by the Village of Wilmette in 1951; it is now supported by the Wilmette Historical Society as well. The museum is located at 609 Ridge Road in a historic building, the 1896 Gross Point Village Hall, which has a fabulous 2004 addition designed by Chicago architect David Woodhouse. This spacious facility provides visitors with a research room and exhibit galleries, as well as a hall for special events, lectures, and programs for children and adults. A lively array of activities is offered throughout the year. We encourage you to visit the museum, where you can enjoy our programs and exhibits and find out more about the photographs in this book as well as about other topics in local history.

Part of the museum's mission is to collect and preserve the history of Wilmette, New Trier Township, and the surrounding area. The photographs used in this book are only a small percentage of the museum's extensive collection of images. Other collections include records of local organizations and governmental bodies, clothing and textiles, three-dimensional objects, newspapers, oral histories and reminiscences, reference files, and records about houses and buildings in town. The majority of items were received from generous donors. If you think you might have something related to life in Wilmette, whether it be from 1870 or 1970, please consider contacting the museum about making it part of the collections. The museum uses these collections to create programs, exhibits, and publications like this one.

Support of the Wilmette Historical Museum is always welcome, and contributions and memberships are an especially good way to support us. To obtain a membership form, or to contact us about any other matter, please call the museum at 847-853-7666, visit our website at www.wilmettehistory. org, or email us at museum@wilmette.com. We look forward to hearing from you, or better yet, seeing you in person.

DISCOVER THOUSANDS OF LOCAL HISTORY BOOKS
FEATURING MILLIONS OF VINTAGE IMAGES

Arcadia Publishing, the leading local history publisher in the United States, is committed to making history accessible and meaningful through publishing books that celebrate and preserve the heritage of America's people and places.

Find more books like this at
www.arcadiapublishing.com

Search for your hometown history, your old
stomping grounds, and even your favorite sports team.

Consistent with our mission to preserve history on a local level, this book was printed in South Carolina on American-made paper and manufactured entirely in the United States. Products carrying the accredited Forest Stewardship Council (FSC) label are printed on 100 percent FSC-certified paper.

MADE IN THE
USA